THE PIERO DELLA FRANCESCA TRAIL

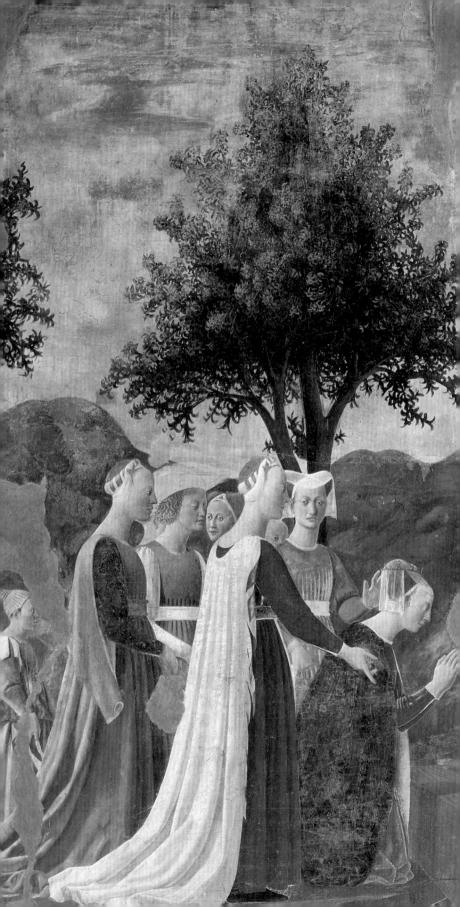

THE PIERO DELLA FRANCESCA TRAIL

JOHN POPE-HENNESSY

WITH

THE BEST PICTURE ALDOUS HUXLEY

THE LITTLE BOOKROOM

NEW YORK

© 1991 Estate of John Pope-Hennessy First published in the United States in 1992 by Thames & Hudson Inc.

"The Best Picture" is from

Complete Essays by Aldous Huxley, Volume I

© 2000 by Ivan R. Dee, Publisher, reprinted by permission.

This is the twenty-third of the Walter Neurath Memorial Lectures which are given annually each spring on subjects reflecting the interests of the founder of Thames & Hudson. The Directors wish to express particular gratitude to the Governors and Master of Birkbeck College University of London for their gracious sponsorship of these lectures.

I did not, to my deep regret, know Walter Neurath. We had, through the books he published, a vicarious relationship, based on admiration for their scope and for the imaginative quality that they revealed. They set standards and changed taste. It was an bonour to deliver this lecture in the series dedicated to his memory.—J P-H

The publisher wishes to acknowledge Eliza Moore, whose fondness for this book inspired this edition.

Cover: Piero della Francesca, Madonna del Parto, Monterchi.

Scala/Art Resource, New York

Frontispiece: Piero della Francesca, The Queen of Sheba Adoring the Wood of the Cross and
The Meeting of Solomon and the Queen of Sheba. San Francesco, Arezzo. Scala/Art Resource,

New York

First Printing: January 2002 Printed in Italy.

All rights reserved, which includes the right to reproduce this book or portions thereof in any portion whatsoever.

Library of Congress Cataloging-in-Publication Data

Pope-Hennessy, John Wyndham, Sir, 1913–1995 The Piero della Francesca trail/John Pope-Hennessy.

p. cm.
Originally published: New York, N.Y.: Thames and Hudson, 1992. With new introd. entitled The best picture by Aldous Huxley.
Includes bibliographical references.

ISBN 1-892145-13-8 (hc : alk. paper)

I. Piero, della Francesca, 1416:-1492—Criticism and interpretation. I. Title.

ND623.F78 P66 2002 759.5—dc21

2001038574

Published by The Little Bookroom 5 St. Luke's Place New York NY 10014 212.691.3321 212.691.2011 fax book-room@rcn.com

Distributed by Publishers Group West; in the UK by Macmillan Distribution Ltd.

THE BEST PICTURE

ALDOUS HUXLEY

ORGO SAN SEPOLCRO IS NOT VERY EASY TO GET AT. There is a small low-comedy railway across the hills from Arezzo. Or you can approach it up the Tiber valley from Perugia. Or, if you happen to be at Urbino, there is a motor 'bus which takes you to San Sepolcro, up and down through the Apennines, in something over seven hours. No joke, that journey, as I know by experience. But it is worth doing, though preferably in some other vehicle than the 'bus, for the sake of the Bocca Trabaria, that most beautiful of Apennine passes, between the Tiber valley and the upper valley of the Metauro. It was in the early spring that we crossed it. Our omnibus groaned and rattled slowly up a bleak northern slope, among bald rocks, withered grass and still unbudded trees. It crossed the col and suddenly, as though by a miracle, the ground was yellow with innumerable primroses, each flower a little emblem of the sun that had called it into being.

And when at last one has arrived at San Sepolcro, what is there to be seen? A little town surrounded by walls, set in a broad flat valley between hills; some fine Renaissance palaces with pretty balconies of wrought iron; a not very interesting church, and finally, the best picture in the world.

The best picture in the world is painted in fresco on the wall of a room in the town hall. Some unwittingly beneficent vandal had it covered, some time after it was painted, with a thick layer of plaster, under which it lay hidden for a century or two, to be revealed at last in a state of preservation remarkably perfect for a fresco of its date. Thanks to the vandals, the visitor who now enters the Palazzo dei Conservatori at Borgo San Sepolcro finds the stupendous Resurrection almost as Piero della Francesca left it. Its clear, yet subtly sober colours shine out from the wall with scarcely impaired freshness. Damp has blotted out nothing of the design, nor dirt obscured it. We need no imagination to help us figure forth its beauty; it

stands there before us in entire and actual splendour, the greatest picture in the world.

The greatest picture in the world. . . . You smile. The expression is ludicrous, of course. Nothing is more futile than the occupation of those connoisseurs who spend their time compiling first and second elevens of the world's best painters, eights and fours of musicians, fifteens of poets, all-star troupes of architects and so on. Nothing is so futile because there are a great many kinds of merit and an infinite variety of human beings. Is Fra Angelico a better artist than Rubens? Such questions, you insist, are meaningless. It is all a matter of personal taste. And up to a point this is true. But there does exist, none the less, an absolute standard of artistic merit. And it is a standard which is in the last resort a moral one. Whether a work of art is good or bad depends entirely on the quality of the character which expresses itself in the work. Not that all virtuous men are good artists, nor all artists conventionally virtuous. Longfellow was a bad poet, while Beethoven's dealings with his publishers were frankly dishonourable. But one can be dishonourable towards one's publishers and yet preserve the kind of virtue that is necessary to a good artist. That virtue is the virtue of integrity, of honesty towards oneself. Bad art is of two sorts: that which is merely dull, stupid and incompetent, the negatively bad; and the positively bad, which is a lie and a sham. Very often the lie is so well told that almost every one is taken in by it—for a time. In the end, however, lies are always found out. Fashion changes, the public learns to look with a different focus and, where a little while ago it saw an admirable work which actually moved its emotions, it now sees a sham. In the history of the arts we find innumerable shams of this kind, once taken as genuine, now seen to be false. The very names of most of them are now forgotten. Still, a dim rumour that Ossian once was read, that Bulwer was thought a great novelist and "Festus" Bailey a mighty poet still faintly reverberates. Their counterparts are busily earning praise and money at the present day. I often wonder if I am one of them. It is impossible to know. For one can be an artistic swindler without meaning to cheat and in the teeth of the most ardent desire to be honest.

Sometimes the charlatan is also a first-rate man of genius and then you have such strange artists as Wagner and Bernini, who can turn what is false and theatrical into something almost sublime.

That it is difficult to tell the genuine from the sham is proved by the fact that enormous numbers of people have made mistakes and continue to make them. Genuineness, as I have said, always triumphs in the long run. But at any given moment the majority of people, if they do not actually prefer the sham to the real, at least like it as much, paying an indiscriminate homage to both.

And now, after this little digression we can return to San Sepolcro and the greatest picture in the world. Great it is, absolutely great, because the man who painted it was genuinely noble as well as talented. And to me personally the most moving of pictures, because its author possessed almost more than any other painter those qualities of character which I most admire and because his purely aesthetic preoccupations are of a kind which I am by nature best fitted to understand. A natural, spontaneous and unpretentious grandeur—this is the leading quality of all Piero's work. He is majestic without being at all strained, theatrical or hysterical—as Handel is majestic, not as Wagner. He achieves grandeur naturally with every gesture he makes, never consciously strains after it. Like Alberti, with whose architecture, as I hope to show, his painting has certain affinities, Piero seems to have been inspired by what I may call the religion of Plutarch's Lives-which is not Christianity, but a worship of what is admirable in man. Even his technically religious pictures are paeans in praise of human dignity. And he is everywhere intellectual.

With the drama of life and religion he is very little concerned. His battle pictures at Arezzo are not dramatic compositions in spite of the many dramatic incidents they contain. All the turmoil, all the emotions of the scenes have been digested by the mind into a grave intellectual whole. It is as though Bach had written the 1812 Overture. Nor are the two superb pictures in the National Gallery—the Nativity and the Baptism—distinguished for any particular sympathy with the religious or emotional significance of the events portrayed. In the extraordinary Flagellation at Urbino, the nominal

subject of the picture recedes into the background on the left-hand side of the panel, where it serves to balance the three mysterious figures standing aloof in the right foreground. We seem to have nothing here but an experiment in composition, but an experiment so strange and so startingly successful that we do not regret the absence of dramatic significance and are entirely satisfied. The Resurrection at San Sepolcro is more dramatic. Piero has made the simple triangular composition symbolic of the subject. The base of the triangle is formed by the sepulchre; and the soldiers sleeping round it are made to indicate by their position the upward jet of the two sides, which meet at the apex in the face of the risen Christ, who is standing, a banner in his right hand, his left foot already raised and planted on the brim of the sepulchre, preparing to set out into the world. No geometrical arrangement could have been more simple or more apt. But the being who rises before our eyes from the tomb is more like a Plutarchian hero than the Christ of conventional religion. The body is perfectly developed, like that of a Greek athlete: so formidably strong that the wound in its muscular flank seems somehow an irrelevance. The face is stern and pensive, the eyes cold. The whole figure is expressive of physical and intellectual power. It is the resurrection of the classical ideal, incredibly much grander and more beautiful than the classical reality, from the tomb where it had lain so many hundred years.

Aesthetically, Piero's work has this resemblance to Alberti's: that it too is essentially an affair of masses. What Alberti is to Brunelleschi, Piero della Francesca is to his contemporary, Botticelli. Botticelli was fundamentally a draughtsman, a maker of supple and resilient lines, thinking in terms of arabesques inscribed on the flat. Piero, on the contrary, has a passion for solidity as such. There is something in all his works that reminds one constantly of Egyptian sculpture. Piero has that Egyptian love of the smooth rounded surface that is the external symbol and expression of a mass. The faces of his personages look as though they were carved out of some very hard rock into which it had been impossible to engrave the details of a human physiognomy—the hollows, the lines and wrinkles of real life. They are ideal, like the faces of Egyptian gods and princes,

surface meeting and marrying with curved unbroken surface in an almost geometrical fashion. Look, for example, at the faces of the women in Piero's fresco at Arezzo: "The Queen of Sheba recognizing the Holy Tree." They are all of one peculiar cast: the foreheads are high, rounded and smooth; the necks are like cylinders of polished ivory; from the midst of the concave sockets the eyelids swell out in one uninterrupted curve into convexity; the cheeks are unbrokenly smooth, and the subtle curvature of their surfaces is indicated by a very delicate chiaroscuro which suggests more powerfully the solidity and mass of the flesh than the most spectacular Caravaggioesque light and shade could do.

Piero's passion for solidity betrays itself no less strikingly in his handling of the dresses and drapery of his figures. It is noticeable, for example, that wherever the subject permits, he makes his personages appear in curious head-dresses that remind one by their solid geometrical qualities of those oddly shaped ceremonial hats or tiaras worn by the statues of Egyptian kings. Among the frescoes at Arezzo are several which illustrate this peculiarity. In that representing Heraclius restoring the True Cross to Jerusalem, all the ecclesiastical dignitaries are wearing enormously high head-dresses, conical, trumpet-shaped, even rectangular. They are painted very smoothly with, it is obvious, a profound relish for their solidity. One or two similar head-dresses, with many varieties of wonderfully rounded helmets, are lovingly represented in the battle-pieces in the same place. The Duke of Urbino, in the well-known portrait at the Uffizi, is wearing a red cloth cap whose shape is somewhat like that of the "Brodrick" of the modern English soldier, but without the peak—a cylinder fitting round the head, topped by a projecting disk as the crown. Its smoothness and the roundness of its surfaces are emphasized in the picture. Nor does Piero neglect the veils of his female figures. Though transparent and of lawn, they hang round the heads of his women in stiff folds, as though they were made of steel. Among clothes he has a special fondness for pleated bodices and tunics. The bulge and recession of the pleated stuff fascinates him, and he likes to trace the way in which the fluted folds follow the curve of the body beneath. To drapery he gives, as we might expect,

a particular weight and richness. Perhaps his most exquisite handling of drapery is to be seen in the altar-piece of the Madonna della Misericordia, which now hangs near the Resurrection in the town hall at San Sepolcro. The central figure in this picture, which is one of the earliest of Piero's extant works, represents the Virgin, standing, and stretching out her arms, so as to cover two groups of suppliants on either side with the folds of her heavy blue mantle. The mantle and the Virgin's dress hang in simple perpendicular folds, like the flutings on the robe of the archaic bronze charioteer at the Louvre. Piero has painted these alternately convex and concave surfaces with a peculiar gusto.

It is not my intention to write a treatise on Piero della Francesca; that has been done sufficiently often and sufficiently badly to make it unnecessary for me to bury that consummate artist any deeper under layers of muddy comment. All I have meant to do in this place is to give the reasons why I like his works and my justifications for calling the Resurrection the greatest picture in the world. I am attracted to his character by his intellectual power; by his capacity for unaffectedly making the grand and noble gesture; by his pride in whatever is splendid in humanity. And in the artist I find peculiarly sympathetic the lover of solidity, the painter of smooth curving surfaces, the composer who builds with masses. For myself I prefer him to Botticelli, so much so indeed, that if it were necessary to sacrifice all Botticelli's works in order to save the Resurrection, the Nativity, the Madonna della Misericordia and the Arezzo frescoes, I should unhesitatingly commit the Primavera and all the rest of them to the flames. It is unfortunate for Piero's reputation that his works should be comparatively few and in most cases rather difficult of access. With the exception of the Nativity and Baptism at the National Gallery, all the really important works of Piero are at Arezzo, San Sepolcro and Urbino. The portraits of the Duke and Duchess of Urbino with their respective triumphs, in the Uffizi, are charming and exceedingly "amusing"; but they do not represent Piero at his best. The altar-piece at Perugia and the Madonna with saints and donor at Milan are neither of them first-rate. The St. Jerome at Venice is goodish; so too is the damaged fresco of the Malatesta, at Rimini. The Louvre possesses nothing, and Germany can only boast of a study of architecture, inferior to that at Urbino. Anybody, therefore, who wants to know Piero must go from London to Arezzo, San Sepolcro and Urbino. Now Arezzo is a boring sort of town, and so ungrateful to its distinguished sons that there is no monument within its walls to the divine Aretino. I deplore Arezzo; but to Arezzo, nevertheless, you must go to see Piero's most considerable works. From Arezzo you must make your way to San Sepolcro, where the inn is only just tolerable, and to which the means of communication are so bad that, unless you come in your own car, you are fairly compelled to stay there. And from San Sepolcro you must travel by 'bus for seven hours across the Apennines to Urbino. Here, it is true, you have not only two admirable Pieros (the Flagellation and an architectural scene), but the most exquisite palace in Italy and very nearly a good hotel. Even on the most wearily reluctant tourist Urbino imposes itself; there is no escaping it; it must be seen. But in the case of Arezzo and San Sepolcro there is no such moral compulsion. Few tourists, in consequence, take the trouble to visit them.

If the principal works of Piero were to be seen in Florence, and those of Botticelli at San Sepolcro, I do not doubt that the public estimation of these two masters would be reversed. Artistic English spinsters would stand in rapturous contemplation before the story of the True Cross, instead of before the Primavera. Raptures depend largely upon the stars in Baedeker, and the stars are more freely distributed to works of art in accessible towns than to those in the inaccessible. If the Arena chapel were in the mountains of Calabria, instead of at Padua, we should all have heard a good deal less of Giotto.

But enough. The shade of Conxolus rises up to remind me that I am running into the error of those who measure merit by a scale of oddness and rarity.

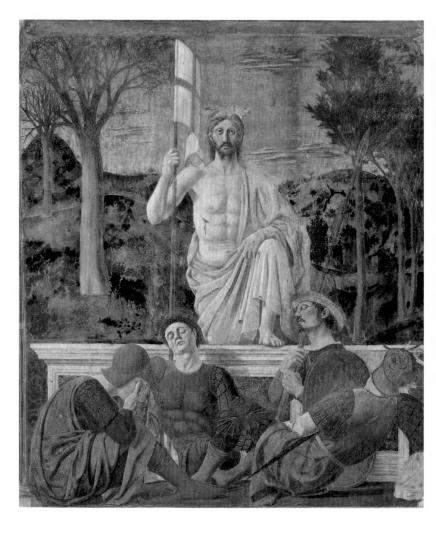

1 Piero: *The Resurrection.* Museo Civico, Borgo San Sepolcro

HERE COMES A POINT IN LIFE when the artists one has known cease to be objects of research and become friends. The workings of their minds assume a taken-for-granted quality that transcends art-historical analysis. When I was invited to deliver the Neurath Lecture, it seemed to me that an appropriate subject would be one of these relationships. But which? I was tempted to talk about Giovanni Bellini, an artist whose bibliography is particularly weak. Very little attention, it seemed to me, had been paid to the structure of Bellini's paintings, and in books on him there is no reference to the architect Mauro Codussi, by whom the thrones in so many of his paintings seem to have been designed. I was tempted also to talk on Donatello and what is called Stilpluralismus, the fact that large sculptural commissions executed over a ten year period retained the form in which they were conceived, while the sculptor'as personal style in the same period underwent a change. But my choice finally fell on Piero della Francesca, because it seemed that a number of obvious questions about his work were never asked and that aspects of his artistic personality had for that reason been misunderstood.

Let there be no mistake about it: Piero is a reclusive, silent, rather taciturn friend. Like most people of my generation, I first heard of him through the written word, in a book of Aldous Huxley's called *Along the Road*, which contained an essay on 'the best picture'. The best picture, one learned, was in a dusty little Tuscan town that few people took the trouble to visit named Borgo San Sepolcro. It was difficult to get there. From Urbino it took Huxley seven hours by bus. There must be some exaggeration there. I did the journey by bus a number of times in the 1930s, and then it took only three. Anyway, the point is quite a simple one. The best picture, a fresco of the *Resurrection*, and its painter, Piero della Francesca, were so little known to Anglo-Saxon visitors as to constitute a private cult.

Things are quite different now. Every summer tens of thousands of people pursue what is called the Piero della Francesca Trail. In a single day they drive successively to Arezzo and Monterchi and Borgo San Sepolcro and Urbino, to see the originals of those masterpieces

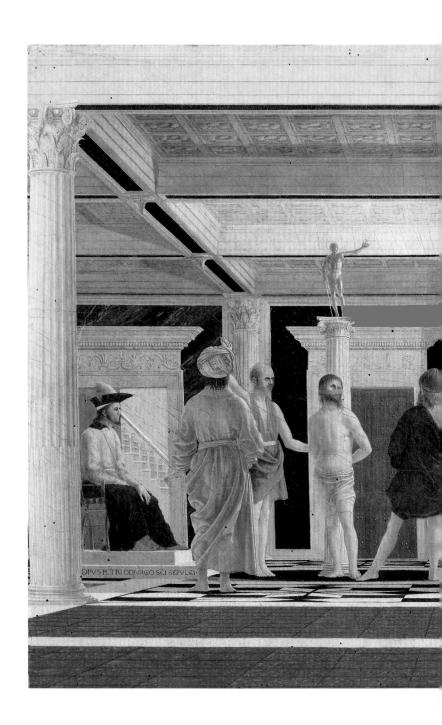

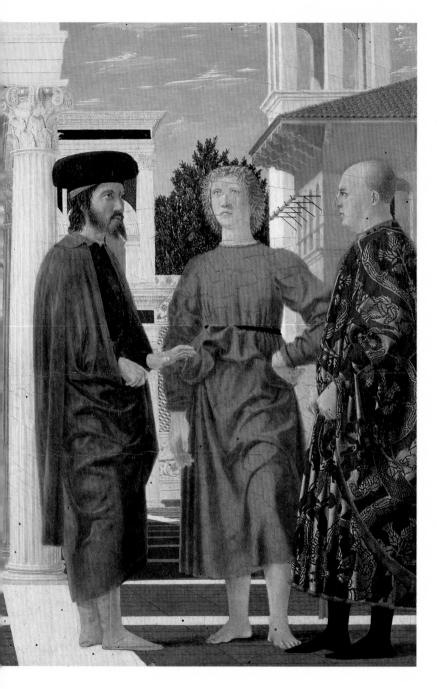

2 Piero: *The Dream of St Jerome* formerly known as *The Flagellation*.

Galleria Nationale, Urbino

that they know from reproductions. In his novel Summer's Lease, John Mortimer describes three tourists leaving their rented house in the Chianti after an early breakfast, so that they 'can do the Resurrection before lunch.'2 They make a perfunctory stop at Arezzo to see the frescoes, and the only one of them who wants to turn the jaunt into an emotional experience—her name is Molly—is puzzled by their style. She sees 'round, invariably handsome, always unsmiling faces, with eyelids that seemed heavy as stone, looking down with perpetual detachment and even, in the case of the women, a kind of contempt.' But she does not look at them for long. 'Not ten o'clock yet, and we've done Arezzo,' says one of her companions. 'It won't take us long to knock off the pregnant Madonna.' And knock it off they do, leaving Molly, in the ugly oratory at Monterchi, scarcely time for some commonplace reflections on her last pregnancy. They go on to San Sepolcro and the Resurrection, where 'you can see what all the fuss was about,' and after a hasty lunch they continue to Urbino and 'the picture Molly had in her mind all the holiday and the one that she had come so far to see.' Once again she finds it disconcerting. 'With one hand on his hip, almost in the same attitude as the pregnant Madonna, the young Lord of Urbino stands, barefoot and serene, between two evil counsellors. What are they plotting, discussing, arguing about? What terrible and irrevocable decision they may have come to, no one can tell. What is certain is that they are far too involved in their own concerns to notice that act of cruelty which is casually, almost elegantly taking place at the other end of the building. Christ is standing, an impassive white figure against a white column. The arms of the flagellators are raised gracefully. Pontius Pilate, in a hat with a long peak, is watching with detachment.' Alas there was no one to explain to Molly that all this is myth—that there is no Christ, no Pontius Pilate, indeed no real flagellation. Neither the gilded classical figure on top of the column, nor the aureole surrounding the victim's head, nor the brilliant light with which this part of the picture is suffused is explicable if the scene depicts the Flagellation of Christ. The subject of the painting, rather, as is proved by comparison with a predella panel in Chicago by a Sienese painter whom

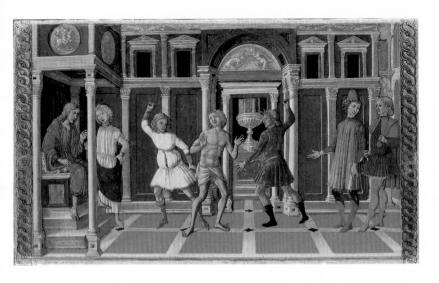

3 Matteo di Giovanni: *The Dream of St Jerome.* Art Institute of Chicago

Piero knew, Matteo di Giovanni, is *The Dream of St Jerome*. As a young man St Jerome dreamt that he was flayed on divine order for reading pagan texts, and he himself later recounted this dream, in a celebrated letter to Eustochium, in terms that exactly correspond with the left-hand side of the Urbino panel.³ The figures on the right-hand side of the picture, therefore—there are two men and a barefoot figure who is an angel—so far from plotting, are discussing the relation between classical and patristic literature embodied in the story of St Jerome's dream. But what exactly, we may ask, is the charisma exercised by an artist, whose repertory of gesture and expression is so ambiguous that the meaning of certain of his paintings has been radically misunderstood?

Naturally, there are shelves of books and articles about Piero that Molly failed to read: a brilliant, poetical volume by Roberto Longhi; an inadequately probing monograph by Kenneth Clark; a fat holdall of a book by Battisti; and a mythomaniacal study, filled with imaginary history, by Carlo Ginzburg.⁴ To these must be added a flotilla of articles, some of them entirely convincing, like Wittkower's and Carter's account of the perspectival structure of the *Dream of St Jerome*, or Carter's of the *Baptism* in the National Gallery, London, or Elkins's of

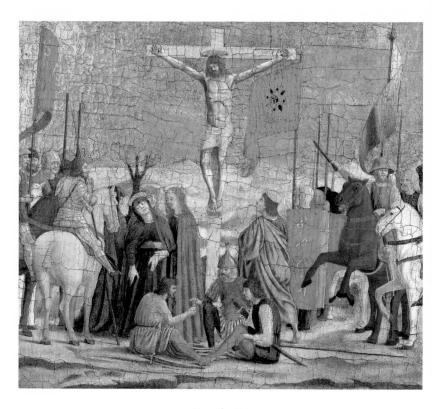

4 Piero: *Crucifixion*.
The Frick Collection, New York

the passages on perspective in Piero della Francesca's *De Prospettiva Pingendi.*⁵ But I want here to take all those as read and, instead, to concentrate on the pictures themselves.

Piero's works are now so widely reproduced that people tend to take them for granted. So I shall begin with a small *Crucifixion*, a minor picture admittedly, which has not been much discussed in its cleaned state. The first thing that strikes one is its geometry. The cross is in the exact centre of the panel and extends to the top edge. Its crosspiece is parallel to the top and bottom edges of the panel, and the arms of Christ beneath it form an inverted triangle. Below, the pattern is repeated in the raised knees of the soldiers sitting on the ground. The vertical shaft of the cross is reinforced by two banners at the sides, and another banner, a red one held by a soldier set on the same plane as Christ, blows lazily in the wind. These devices establish the depth of

the platform on which the scene takes place. The panel is closed at either side by horsemen. Their horses, though two of them are shown in simulated movement, are not rendered naturalistically but seem, rather, to have been carved out of wood. In the centre, on the rocky ground, are two holy women, St John and two soldiers, all of whose heads are on the same level as the feet of Christ and fall on a horizontal drawn through the middle of the panel. Behind them is a desert that extends through barren distance till, at the horizon, on the level of Christ's knees, it merges into the golden sky. The scene is instilled with feeling, but feeling under a tight rein.

This little panel comes from the bottom of a disassembled altarpiece of which other parts survive. It was painted for a church, Sant'Agostino, in Piero's native town of Borgo San Sepolcro, and the commission for it dates from 1454. We might guess without any other evidence that the predella was painted slowly, and so was the whole altarpiece. Work on it continued for fifteen years. The central panel, a Virgin and Child, has disappeared (though since the side panels survive it will, no doubt, eventually turn up) and what we have today are four full-length standing saints, in London, Lisbon, Milan and New York, as well as a few unimportant subsidiary panels. In each case the saint, outlined against the deep blue sky, stands on a balcony with, behind him, a balustrade formed of squares of coloured marble framed by pilasters with a classical frieze at the top. It is as though the saints were standing on some imaginary loggia in the Ducal Palace at Urbino. Two of them, as we might expect, are Augustinians, St Augustine himself and St Nicholas of Tolentino, who had been canonized eight years before; another, the St Michael in London, refers to the donor's name, Angelo, and the fourth, a saint reading a book in the Frick Collection in New York, is probably the patron of the donor's brother, St Simon. The balustrade serves as a rear plane against which the volume of the heavy figures can be read. The weightiest is St Nicholas of Tolentino, whose habit falls just short of the ground so that the coloured paving beneath him is fully visible. His belt is uncomfortably tight, which is another way of saying that the figure is embarrassingly tactile, and his

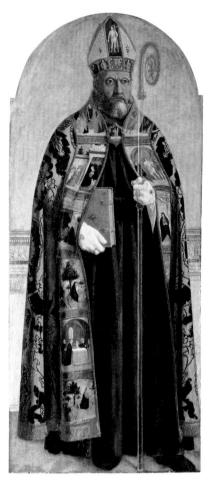

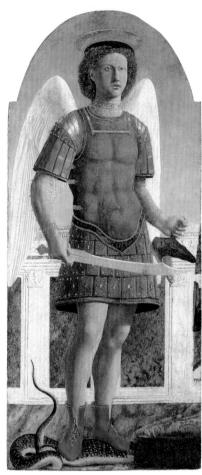

Piero: Four Saints, painted for the altarpiece of Sant'Agostino in Borgo San Sepolcro, and now dispersed. 5 St Augustine. Museu Nacional de Arte Antigua, Lisbon; 6 St Michael. National Gallery, London

perspective halo establishes the solidity of his beautifully sculptured head. Probably this is a portrait. There was no authorized iconography of St Nicholas—he took a long time being canonized—and the artist was free therefore to extemporize. But it is a generic portrait, in which the features are constructed rather than described. That is true also of the hands. Until I compared them with my own hands not long ago in the Poldi-Pezzoli in Milan, I had never realized quite how schematic they really were. All of the saints are impassive and remote, but in none is there so little movement potential as in the St Augustine. He wears a cope and a pearl-studded mitre, and in his hands he holds a crystal

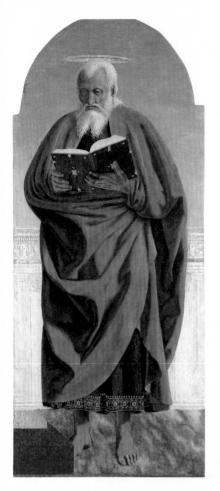

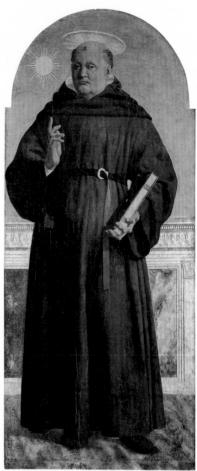

7 St John the Evangelist [St Simon (?)], The Frick Collection, New York; 8 St Nitholas of Tolentino. Museo Poldi–Pezzoli, Milan

crozier with a foreshortened crook. I am no friend to iconographers, but the imagery of this figure just cannot be ignored. Embroidered on the mitre is the blood of the Redeemer, the morse joining the cope has an enamel of the Resurrection, and on the orphrey of the cope itself is a series of Christological scenes running from the Annunciation to the Crucifixion, including (by implication) the Deposition and the Entombment which a fold in the cope conceals from view. These little scenes are miracles of spontaneity, but they are generally given to Piero's workshop, on the ground that they are painted casually. I doubt if that is quite correct, and if they are compared with the

9 Piero: Presentation in the Temple and Agony in the Garden, detail from the cope of St Augustine (pl. 5)

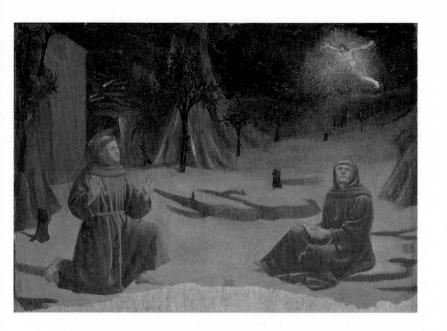

10 Piero: St Francis Receiving the Stigmata. Galleria Nazionale, Perugia

freely painted figures in a late predella panel by him of *St Francis Receiving the Stigmata*—it is in Perugia and dates from about 1470—the judgment seems unsound.

Piero was born about 1420 at Borgo San Sepolcro and must have been in his early forties when the St Augustine was produced. Today, we think of San Sepolcro as Florentine, but it was papal property at the time of Piero's birth and was acquired by Florence, through purchase, only in 1441. Politically its affiliations were Ghibelline, not Guelf, and when pictures were commissioned there they were usually ordered, regardless of distance, from the Ghibelline city of Siena, not from Florence. The most famous work commissioned for it was the great altarpiece of the Sienese painter Sassetta which was installed in 1444 in the church of San Francesco. A Madonna enthroned, now in the Louvre, was the centre of the front face, and the famous St Francis at Villa I Tatti (and a magical figure it is) was the centre of the back. They, and the narrative scenes from the back, most of which are in London, must have exercised a deep influence on Piero. San Sepolcro

11, 12 The central panels of the front and back of Sassetta's altarpiece for San Francesco, Borgo San Sepolcro, Madonna Enthroned. Louvre, Paris; and St Francis in Ecstasy. Villa I Tatti, Florence

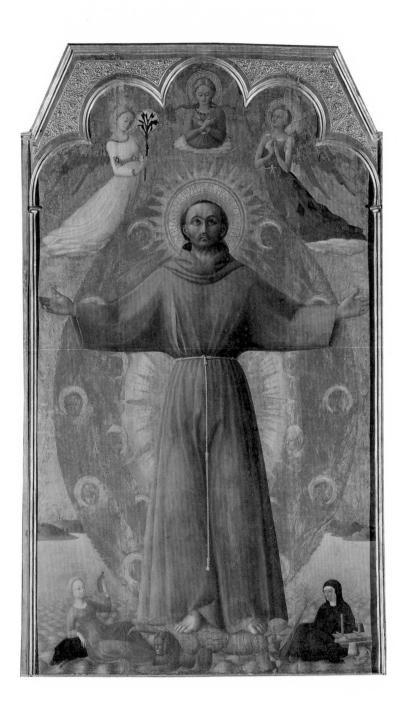

was not (as writers on Piero tend to suggest) a primitive little country town; in its modest way it was a humanist centre and it formed a focus for Piero's work through his whole life. A posthumous portrait painted there shows him standing beside a table with volumes of Euclid and Archimedes, and bears the inscription Pictvrae arithmeticae geometriae amplificator, one who extended the bounds of painting, of arithmetic and of geometry. A skeleton of theory underlies all his works-it is more evident in his expository drawings than in his paintings—and his services were in continuous demand at the humanist courts of central Italy, though in only two of them, at Rimini and at Urbino, does his work survive. No trace remains of the frescoes he executed about 1450 for Ferrara or of his activity in the Vatican in 1459, and we must always remember that what we look on as his most important paintings, the frescoes at Arezzo, would not necessarily have been so regarded in the fifteenth century. His house at San Sepolcro was decorated with classical frescoes, one of which, a challenging figure of Hercules in the Gardner Museum in Boston, still survives.

As we might expect he was trained locally, and we first find him working in 1436 on paintings at San Sepolcro (papal insignia to go over the four gates of the town).⁶ But three years later he was in Florence, working, briefly it seems, with a newcomer from Venice, Domenico Veneziano.

Florentine painting about 1440 was in the throes of change. Perhaps the best way to define the nature of this change is to compare two major altarpieces, one painted by Masaccio for Pisa in 1426 and the other painted by Domenico Veneziano for the church of Santa Lucia, in Florence, between about 1440 and 1445. The earlier, and by far the greater, painting is forceful, realistic and empirical; the later is suave, elegant and controlled. This metamorphosis was due to the influence of one man, the architect and writer on art theory, Alberti, who arrived in Florence when Eugenius IV set up his court there in 1434. His dogma was described in a small book, *On Painting*, written in Latin in 1435 and rewritten a year later in Italian. The *St Lucy Altarpiece* of Domenico Veneziano is the first Florentine painting based, in its

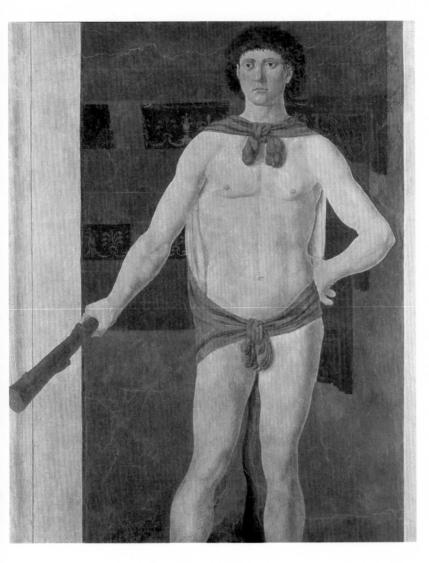

13 Piero: *Hercules*. Isabella Stewart Gardner Museum, Boston

14 Masaccio: Virgin and Child. National Gallery, London

totality, on the ideas Alberti generated. For Alberti the art of painting consisted of circumscription, composition and the reception of light:

In the first place [he says] when we look at a thing we see it as an object which occupies a space. The painter will draw around this space, and he will call this process of sketching the outline circumscription. Then, as we look, we discern how the several surfaces of the object are fitted together; the artist, when drawing these combinations of surfaces in their correct relationship, will properly call this composition. Finally, in looking we observe more clearly the colours of surfaces; the representation in painting of this aspect, since it receives all its variations from light, will aptly here be termed the reception of light.

15 Domenico Veneziano: St Lucy Altarpiece. Uffizi. Florence

What this implies can be seen in the *St Lucy Altarpiece*. The main panel has been impaired by abrasion and by cleaning, so that the forms look less substantial and the paint surface more textureless than they originally did. In front, on a tessellated pavement, stand two pairs of saints. Immediately behind them, on a raised step with marble inlay, there rises a double colonnade with Gothic arches resting on thin columns. Its anything but realistic capitals are pink and its ceiling is pale green. For Alberti, figures were objects in space. Each of the saints in Domenico Veneziano's altarpiece is a sublime still life, and Piero della Francesca's figures, though they are far more vigorously modelled, are conceived in the same way. Passing to colour, 'Plain surfaces', Alberti writes,

keep a uniform colour over their whole extent, while spherical and concave surfaces vary their colours . . . He [the painter] will first begin to modify the colour of the surface with white or black, as necessary, applying it like a gentle dew to the borderline. Then he will go on adding another sprinkling, as it were, on this side of the line, and after that another on this side of it, and then another on this side of this one, so that not only is the part receiving more light tinged with a clearer colour, but the colour also dissolves progressively like smoke into the areas next to each other.⁸

Alberti believed, too, in a system of colour harmony. 'There is a kind of sympathy among colours, whereby grace and beauty are increased when they are placed side by side . . . Dark colours acquire a certain dignity when set between light colours, and similarly light colours may be placed to good effect among dark.'9 In the predella of the *St Lucy Altarpiece* the application of the colour follows the calculated, decorative method Alberti describes, and that method was followed by Piero della Francesca.

In 1439, when Piero della Francesca joined his shop, Domenico Veneziano was engaged on what was probably his most important work, a fresco cycle of scenes from the life of the Virgin in the church of Sant'Egidio. Vasari describes them as though they were secular decorative paintings. The frescoes have disappeared except for a few of the feet, but those are enough to show that what was actually involved was a new type of fresco painting. The basis of the scheme was an academic perspective construction, in which the space recession was logical and perfectly controlled, and the execution was laborious and cogitated. It made use of linseed oil, probably as a binder for secco painting (additions made after the fresco had dried) or glazing. From a perspectival and figurative point of view Piero della Francesca was a far more adventurous, far more innovative artist, but it was Domenico Veneziano's technique that he employed in his key works, the frescoes in the choir of San Francesco at Arezzo.

Considering how familiar they are, our knowledge of them is

woefully inadequate. San Francesco is today, and was in the fifteenth century, a barrack-like conventual church of no architectural distinction, filled with a miscellany of undistinguished provincial frescoes. Rights over the high altar were vested in a local family, the Bacci, and the decoration of the choir was financed by contributions from three separate branches of the family. The last contribution was delivered in 1447. The subject chosen for the choir frescoes was one confined to Franciscan churches, the Legend of the Cross, the story of how the wood of the Cross was employed in the building of the palace of Solomon; was recognized by the Queen of Sheba; was buried and later recognized by the Empress Helena, the mother of the Emperor Constantine; was returned to Jerusalem; was stolen by Chosroes; and was returned once more to Jerusalem by Heraclius. At first work was entrusted to a conservative, time-expired Florentine painter, Bicci di Lorenzo. He painted the ceiling of the choir, and began work on the entrance arch and on the upper register of one wall. But early in 1448 he left Arezzo, and in 1452 he died. When he stopped work, the nature of the whole commission changed. What had started as a typical example of unenlightened local taste was transformed into a scheme whose sheer sophistication had no equivalent in Florence or elsewhere in central Italy. In Florence there was an Aretine mafia—it included the state secretary, Leonardo Bruni, and his successor Carlo Marsuppini and one of its members was Giovanni Bacci, to whom the revision of the scheme for the frescoes in San Francesco may have been due. In some books we are told that work started after Bicci di Lorenzo's death in 1452 and was finished in 1459, and in others that the frescoes were planned in 1461 and executed between the Spring of 1463 and December of the following year. The only firm date we have is 1466, when Piero is referred to as the artist who had painted the frescoes. In practice the options for dating the frescoes are a good deal wider than books on Piero suggest. There is no reason to suppose that the contract with Bicci di Lorenzo remained in force until the painter's death, and Piero's frescoes could well have been begun in or soon after 1448, when Bicci di Lorenzo stopped work and returned to Florence. To us today they

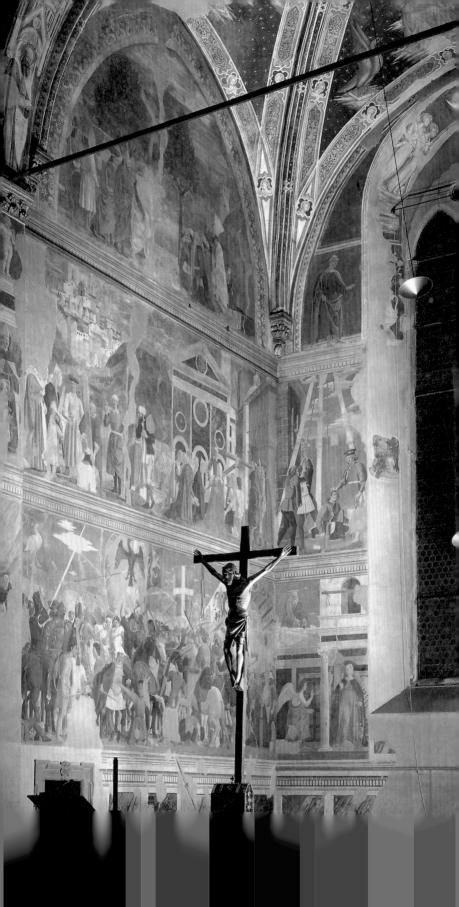

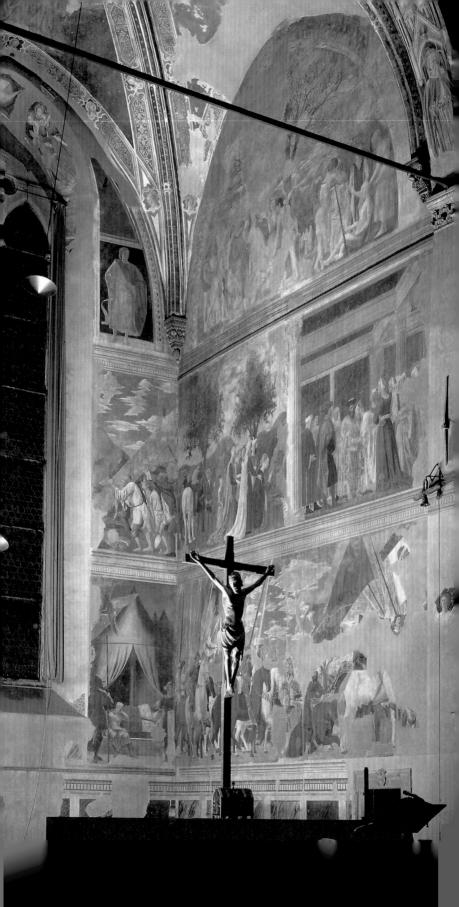

appear a commission of great consequence, but work on them seems to have given way to the commissions Piero received from more powerful patrons, the Este at Ferrara and Sigismondo Malatesta at Rimini. Probably they were interrupted once again in 1459 when he was painting in the Vatican. Any decision on the date of the cycle has therefore to rest, first on examination of the frescoes themselves and second on the coefficient of works by Piero that are securely datable. Two of them are relevant, the first an altarpiece commissioned for the Misericordia in Borgo San Sepolcro in 1445, work on which must have continued till after 1450 since it includes a figure of the newly canonized San Bernardino, and the second a fresco at Rimini of Sigismondo Malatesta kneeling before St Sigismund, which in the eighteenth century was still inscribed with the date 1451. In the light of these two paintings it seems that work at Arezzo started earlier than is generally supposed, probably in 1448, and was pursued in a second campaign after Piero returned from Rimini.

Each of the lateral walls at Arezzo contains three superimposed frescoes, and the common assumption is that they were painted from a scaffolding stretching across the choir from one wall to the other, which was lowered as work progressed. Each pair of confronting frescoes would therefore have been produced in close proximity. On stylistic as well as physical grounds, this view is indefensible. The subject of the lunette at the top of the left wall is Heraclius Restoring the Cross to Jerusalem, celebrated in the Church by the feast of the Exaltation of the Cross. The composition depends in part on a fresco by Agnolo Gaddi in the choir of Santa Croce in Florence, and the sinopia (the roughed out drawing on the wall) may have been prepared by Bicci di Lorenzo, through the execution is by Piero. The centre of the composition is an empty landscape, and the figures occupy, on the left, a shallow and, on the right, a somewhat deeper platform. At either side the Emperor and two men behind him wear cloaks resolved in nervous, rounded folds. If the upper line of the city wall on the right and the line beneath the knees of the kneeling figure to the right of centre are protracted they meet at a vanishing point in the centre about a fifth of

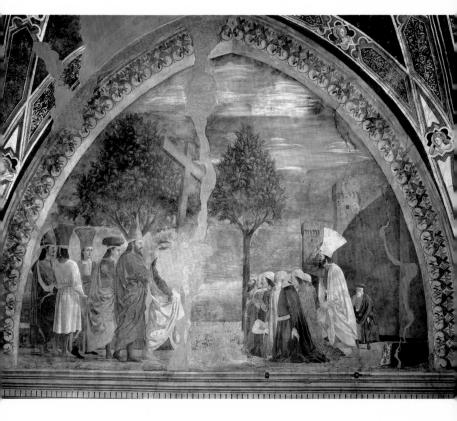

18 Piero: Heraclius Restoring the Cross to Jerusalem. Arezzo

the height of the fresco field. Ten of the figures are shown in profile. This is, in other words, a competent, conventional scheme. Very different is the magnificent lunette on the right wall. It shows three separate scenes: Adam announcing his death; Seth's visit to the angel; and the planting of the Tree of Salvation in Adam's mouth.

Seth's visit to the Angel is shown in the distance a little to the right of centre. The two other scenes are distributed across the foreground. The larger, the death and burial of Adam, fills the whole area between the left edge and the centre of the fresco, and the smaller, the five figure group of Adam announcing his death, occupies the right third of the field. The two unequal blocks of figures are unified by the thick trunk of a tree, beneath which stands a woman with arms outstretched in what reads as a prevision of the Crucifixion. The depth of the foreground is established by the disposition of the figures in monumental poses of astonishing variety. The drapery forms are weighty and authoritative; the heads are more expressive than in the fresco opposite and are lit with greater subtlety. There are no predominant profiles, and the scene on the right exactly follows the prescription of Alberti for the construction of figure groups:

Let there be some visible full-face, with their hands turned upwards and fingers raised, and resting on one foot; others should have their faces turned away, their arms by their sides, and feet together, and each one of them should have his own particular flexions and movements. Others should be seated, or resting on a bended knee, or almost lying down. If suitable, let some be naked, and let others stand around, who are halfway between the two, part clothed and part naked.¹⁰

The second register on the left-hand side is devoted to the Discovery and Proof of the Cross. In both scenes the space illusion is less strong. The two crosses, at different angles of recession, establish the depth of the figurated area. Behind the Discovery of the Cross is a geometrical vision of Jerusalem, and behind the Proof of the Cross is the polychrome marble façade of a church with two receding palaces in a street on the extreme right. This is not a populated street, like the streets in

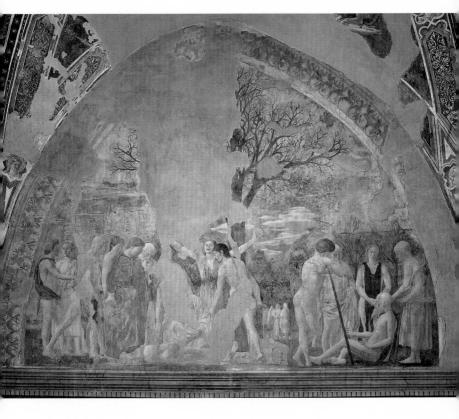

19 Piero: *The Death of Adam.* Arezzo

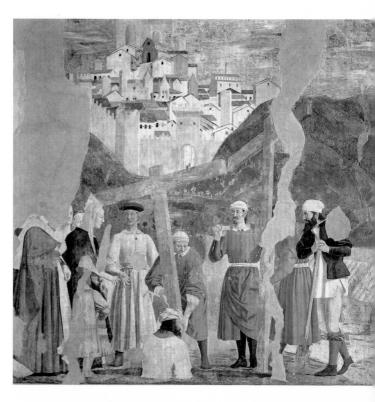

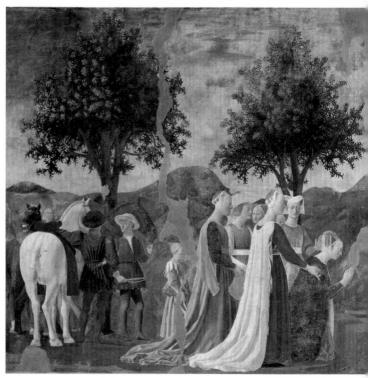

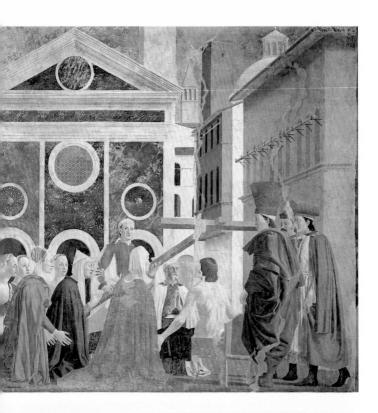

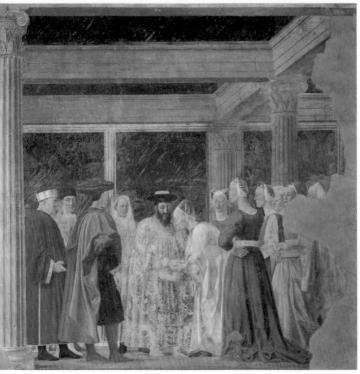

20, 21 Piero: The Discovery and Proof of the Cross; The Queen of Sheba Adoring the Wood of the Cross and The Meeting of Solomon and the Queen of Sheba.

Arezzo

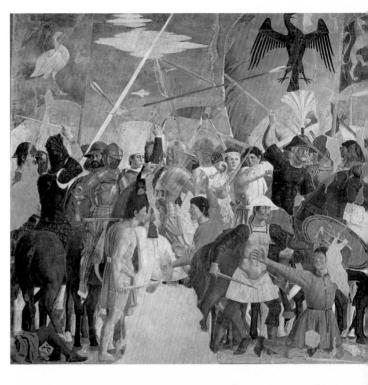

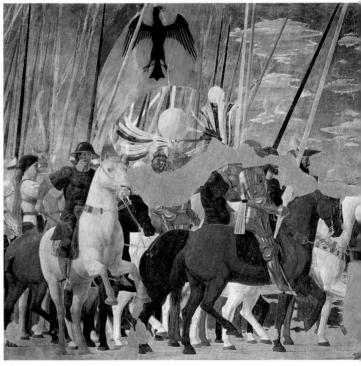

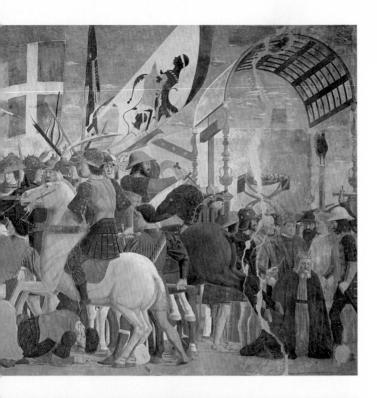

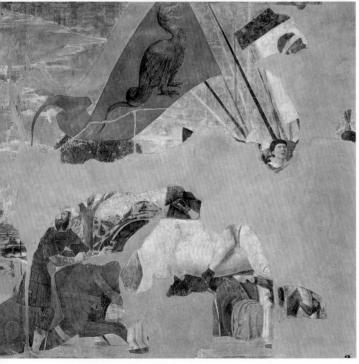

22, 23 Piero: The Victory of Heraclius over Chosroes; The Victory of Constantine over Maxentius.

Arezzo

Fra Angelico's Burial of Saints Cosmas and Damian or Domenico Veneziano's Miracle of St Zenobius. It is a backcloth, and the action, hemmed in by kneeling figures at one side and by standing figures at the other, takes place in an area delimited by the bier and the extended cross. The corresponding fresco on the right wall portrays two discrete scenes, the Queen of Sheba recognizing the wood of the Cross, and her meeting with Solomon, linked in a single perspective structure, which has its vanishing point in the main focus of narrative action, the Queen kneeling before the entrance to the palace. On the left there extends a spacious landscape parsed metrically with two trees, and to the right Solomon receives the Queen and her cortège advancing from the opposite side of the fresco in what has been claimed, very plausibly, as a depiction of the lower loggia of the Septizonium.

In the lowest register the contrast between the two walls is still more pronounced. Through the centre and left side of the fresco of the *Victory of Heraclius over Chosroes* the space is figure-constructed space, in which the depth is established by the reduced size of the heads and the diminution in scale of the banner and weapons silhouetted against the sky. From the right the perspective structure of the throne of Chosroes leads the eye to a vanishing point in the centre of the foreground. The individual participants in the battle, though portrayed in active poses, are static and motionless.

Very different is the magnificent *Victory of Constantine over Maxentius*, where the depth occupied by the advancing army on the left is established with unambiguous clarity by the legs of the horses and the carefully calculated pattern of lances against the sky. The range of expression in the heads, by comparison with the battle scene opposite, is more lifelike and more clearly differentiated.

There is one other major difference between the planning of the two walls. That on the right is constructed with a central axis which descends from the Tree of Life in the lunette to the wood of the Cross and thence to the Cross held by Constantine. On the left no such axis is established, and the three scenes are compositionally disassociated. Some difference in quality between the two walls is acknowledged by

writers on Piero. For Kenneth Clark, for example, 'The east wall begins with a scene—Heraclius bringing the Cross to Jerusalem—which is largely executed by pupils . . . Even in the Discovery there are traces of pupils' work, and the final battle is full of it.' The technique of fresco alone makes it risky to speak of 'pupils' work', and the only admissible conclusion is that the left wall at Arezzo was designed and executed before the right, and that the scaffolding from which it was executed was confined to that wall, and did not extend over the whole width of the choir.

The early dating of the frescoes on the left wall at Arezzo is confirmed by the polyptych commissioned in 1445 for the Misericordia at Borgo San Sepolcro, where the two saints on the left, Sebastian and John the Baptist, were painted about 1447, while the Saints Andrew and Bernardino opposite date from after 1450. The differences between them can be measured not simply in the tentative treatment of the naked St Sebastian, but in the contrast between the Baptist, whose cloak is resolved in loose, disordered folds, and the St Andrew, where the disposition of robe and cloak is heavy and logical. The crumpled folds and unclear forms of the cloaks worn by Heraclius and his followers in the left-hand lunette at Arezzo correspond with the earlier saints in the polyptych, not with the later ones.

The only work by Piero that is datable with absolute precision is the fresco at Rimini, whither he was summoned by Sigismondo Malatesta in 1450 or 1451. Malatesta had made a vow to construct, in the church of San Francesco, a chapel dedicated to his patron saint, St Sigismund. The construction of the chapel was authorized by the pope, Nicholas V, in 1448, and from it there sprang a plan for the reconstruction by Alberti of the whole exterior of the church. Save for the very earliest of the sculptures, the entire decoration of the Tempio bears the stamp of Alberti's designing mind; it is to him that the use of Neo-Attic and other classical models for the low relief sculptures on the piers and the incomparably lucid space articulation of the nave are due. Piero's fresco was not painted for the Chapel of St Sigismund, where there was no wall space, but for the chapel of the relics next

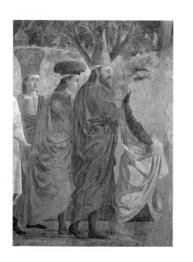

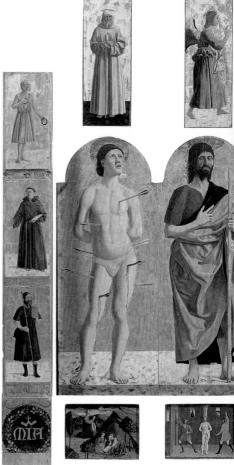

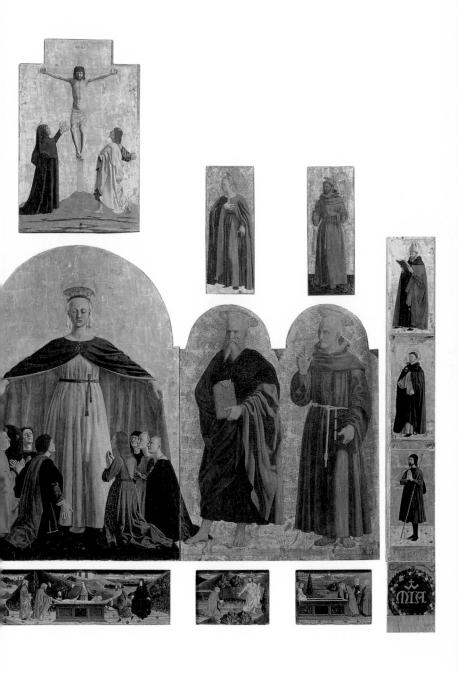

24, 25 Piero: Madonna della Misericordia. Museo Civico, Borgo San Sepolcro with (left) a detail from pl. 18

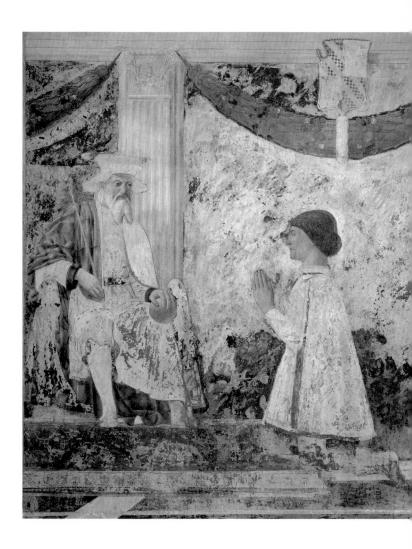

door. Round it there runs a wide frame with simulated relief ornament that Alberti could have devised, and below is a fictive marble moulding containing an inscription. The two figures are set on a shallow stage with a receding marble roof, supported by heavy piers with shallow pilasters on their front faces and garlands hanging between them. At the front, at either side of the inlaid marble floor, are strips of light and dark marble of equal width, which form the module of the composition; they represent one fifteenth of its total width. The white marble strips also serve as perspective guide lines or orthogonals, with a vanishing point in Sigismondo Malatesta's head. The centre of the fresco is established by a band tied round the central garland, and a

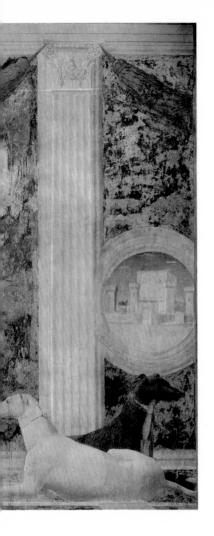

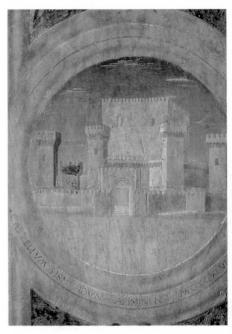

26, 27 Piero: Sigismondo Malatesta kneeling before St Sigismund. San Francesco, Rimini, with (right) view of the Castle of Rimini in the tondo

plumb line dropped from this point would be equidistant from the tip of Sigismondo's extended foot and the forward edge of his praying hands. On the left, on a carpeted step, is St Sigismund seated on a fald-stool, and opposite him on the right is a circular window containing a view of the castle of Rimini seen beneath a pale blue sky. The view through the window is lit from a light source that is unrelated to the light source of the body of the fresco. Though the image is symbolic, it is treated with deceptive naturalness.

In no previous work by Piero is space handled with the mastery with which it is treated here. Not only is the structure more precisely articulated than that of the *Proof of the Cross* at Arezzo, but it embodies

almost all the structural skills that make the *Meeting of Solomon and the Queen of Sheba* the masterly design it is. Work at Arezzo therefore is likely to have been broken off in 1449 when one wall had been completed, in favour first of the lost frescoes at Ferrara—all that we know of them derives from local frescoes by Tura and Cossa that depend on them—and then of the fresco at Rimini, and must have been continued, in the 1450s, in a second campaign on the right wall.

Earlier fresco cycles of the Legend of the Cross occur in the choir of Santa Croce in Florence and at Volterra, where the disposition of the scenes is chronological. But at Arezzo the chronology of the Golden Legend was, in the interest of liturgy, deliberately violated. The narrative starts with the lunette on the right wall, The Death of Adam, continues with the scene beneath it, The Meeting of Solomon and the Queen of Sheba, then moves to the right side of the altar wall, with, above, The Burial of the Wood of the Cross and, beneath, The Dream of Constantine. It is continued on the lower register of the right-hand wall with The Victory of Constantine over Maxentius, passes to the upper register of the left side of the altar wall, with The Torture of Judas, moves on to the central register of the left hand wall, with The Discovery and Proof of the Cross, descends to the lowest register of the same wall, with The Victory of Heraclius over Chosroes, and ends with the lunette on the left wall, with Heraclius Restoring the Cross to Jerusalem. The left wall had priority because it contains frescoes related to the two great Franciscan feasts of the Invention and the Exaltation of the True Cross, whereas the right wall had no liturgical significance. The distribution of the scenes on the lateral walls was clearly decided on before work started on the frescoes. It had the effect of juxtaposing, on opposite sides of the choir, the two scenes of the Discovery of the Wood of the Cross by the Queen of Sheba and the Empress Helena, and the two crusading scenes of Constantine and Heraclius. Was this a didactic, propagandist decision or an aesthetic choice? In books on Renaissance painting one reads a great deal about what are described as programmes, but this is a programme with a vengeance. The chronology of the Golden Legend is set aside so that a relationship can be established across the

choir between each pair of scenes. Not only is the representation of the legend less complete than it had been in Santa Croce, but the emphasis within the cycle is changed. At Arezzo the conventional Dream of Heraclius becomes the Dream of Constantine. A number of links in the narrative chain are missing—there is, for example, no representation of the theft of the Cross by Chosroes—and the scenes that are illustrated therefore carry a greater weight of meaning than they would have done had they been phases in a more extensive narrative.

In looking at the frescoes sequentially one point must be borne constantly in mind, that Piero della Francesca was not, by training, a descriptive artist. In the *Madonna della Misericordia* at Borgo San Sepolcro the heads of the kneeling figures beneath the virgin's cloak are distinguished from each other in age but, save for a middle-aged male figure in profile on the left and an elderly woman opposite, are not individualized, and the overt expression of emotion is confined to two figures at the front, a youth pleading with the Virgin with hands extended at his sides and a woman to the right with hands clasped in prayer. Since the heads of both figures are turned towards the Virgin, their emotion is not stated but implied. The Virgin is conceived in what are called sculptural terms, but is unlike any contemporary sculpture. Her symmetrical, impassive, meticulously modelled head finds its first sculptural equivalent in carvings by Agostino di Duccio produced in the early 1450s at Rimini under the influence of Alberti.

Piero's first task at Arezzo was the working up or adaptation of the *sinopia* of *Heraclius Entering Jerusalem*. Its prototype, Agnolo Gaddi's fresco in Santa Croce of *Helena Entering Jerusalem*, is planned as narrative. The recipients of the Cross lean forward eagerly as the procession from the left approaches them. In the comparable group on the right of Piero's fresco there is no movement. Six of the figures (all of them, indeed, save a small figure in the background) are shown in profile, and opposite them Heraclius and three of his followers are depicted in the same way.

Alberti, in one of the best known passages of the *Della Pittura*, declares that movements must be suave and graceful and adapted to the

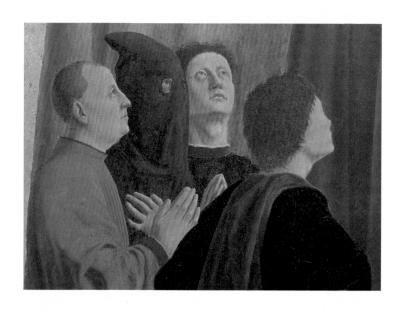

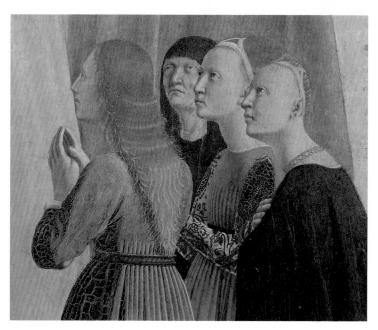

28, 29 Details of male and female heads from the Madonna della Misericordia (pl. 24)

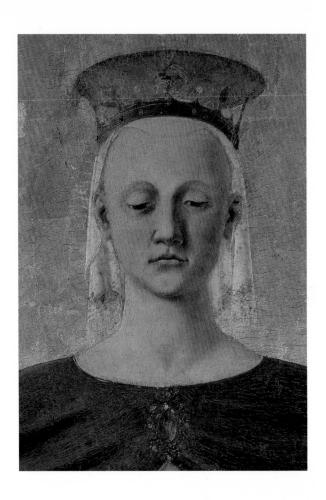

30, 31 Detail of the Madonna's head from the *Madonna della Misericordia* and from a relief by Agostino di Duccio. Victoria and Albert Museum, London

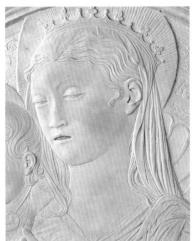

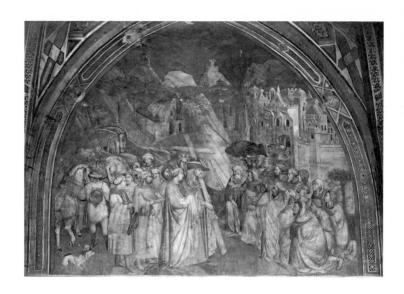

32 Agnolo Gaddi: *Helena Entering Jerusalem*. Santa Croce, Florence

function the figures are intended to fulfil. This advice is central to Piero's scene of the *Discovery and Proof of the Cross*. On the right the contours (or what Alberti calls circumscription) of the kneeling women are faultlessly defined. The composition constructed round them is circular, and the arcades of the façade behind serve to isolate their heads. Above, an emphatic central roundel establishes the primacy of the figure immediately beneath it, Helena. The members of dead figures, Alberti insists, must appear dead even to their fingernails. That challenge is accepted on the extreme right of the fresco in the body of the youth raised from the dead.

The adaptation of Alberti's doctrines to the world of action was a harder task. In design the *Victory of Heraclius over Chosroes* seems to have been inspired by an antique, possibly Etruscan, battle sarcophagus, but the careful handling of individual figures deprives them of the animation of sarcophagus reliefs. In the foreground to the left of centre is a youth kneeling on the ground about to be despatched by a soldier standing over him. His face, turned towards his assailant, registers fear, and fear is embodied in the gesture of his right hand and arm. But in the total context of the scene the figure, like the one on

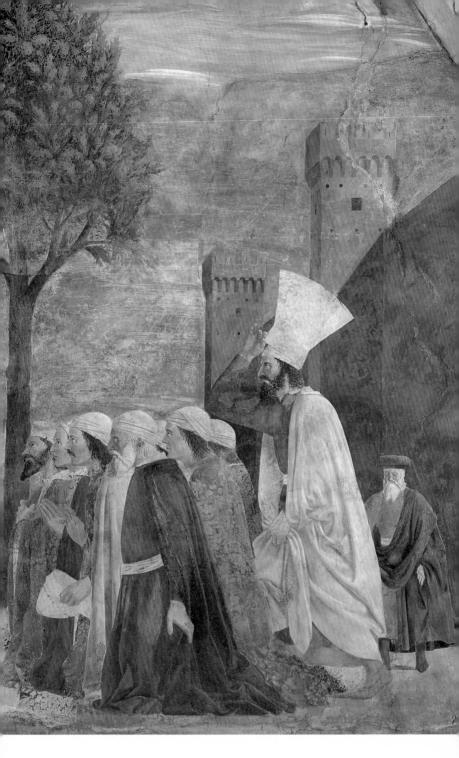

33 Piero: Detail from Heraclius Restoring the Cross to Jerusalem (pl. 18)

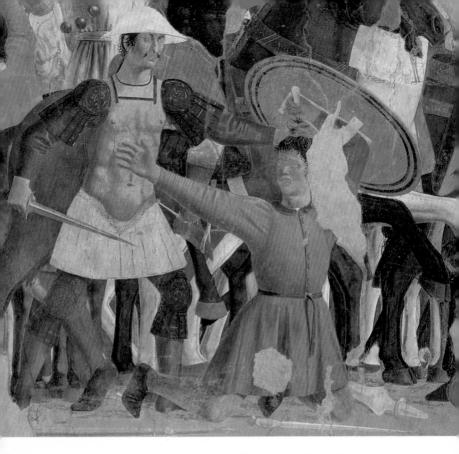

34 Piero: Kneeling youth, detail from The Victory of Heraclius over Chosroes (pl. 22)

the right, reads as a construction, not as a film strip. The same is true of the rearing grey horse in the foreground to the right.

Crossing the choir to the right wall, we enter another world. In the scene of Adam announcing his death on the right of the lunette the influence of Albertian theory is clearly evident. There are two nudes, of different ages, one of whom rests his weight on his left foot; there is a partially nude figure of intermediate age; two figures are in profile, one in full face, one in three-quarter face, and the nude on the left of the group has his head turned away.

But the fresco is far from academic. By the time he started work on the right wall Piero della Francesca had become a great interpretative artist. He was concerned with theory, but with theory as a method of communication. The emotion we experience before the scene of Adam announcing his death arises from the solemnity of the scene as ritual, and ritual is the keynote of the scenes beneath, the Queen of

Sheba's recognition of the Wood and her meeting with Solomon. If we knew nothing of the story, the two parts of Piero's fresco would leave us in no doubt as to the gravity of the events portrayed. The still schematic depiction of the Empress Helena on the wall opposite gives way, in the Queen of Sheba, to a protagonist of superb confidence, who invests the legend with a weight of meaning it had never previously enjoyed. Silence is absolute. The only verbal contact in the left half of the fresco is between two grooms in the middle ground on the left, and on the right the message delivered by the Queen to Solomon is intimated but not described.

The scene of Constantine's Victory over Maxentius in the lowest register has the same clarity. In contrast to The Victory of Heraclius over Chosroes on the facing wall there is an omnipresent sense of space. The figures are confined to the lower half of the fresco field, and the spears

35 Piero: Adam announcing his death, detail from *The Death of Adam* (pl. 19)

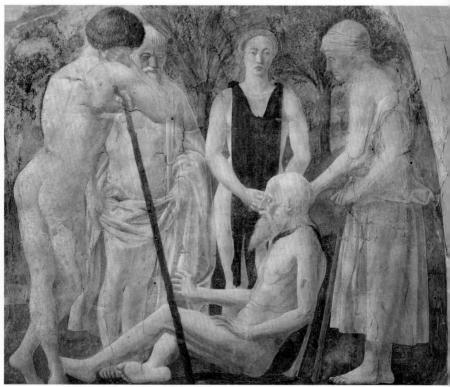

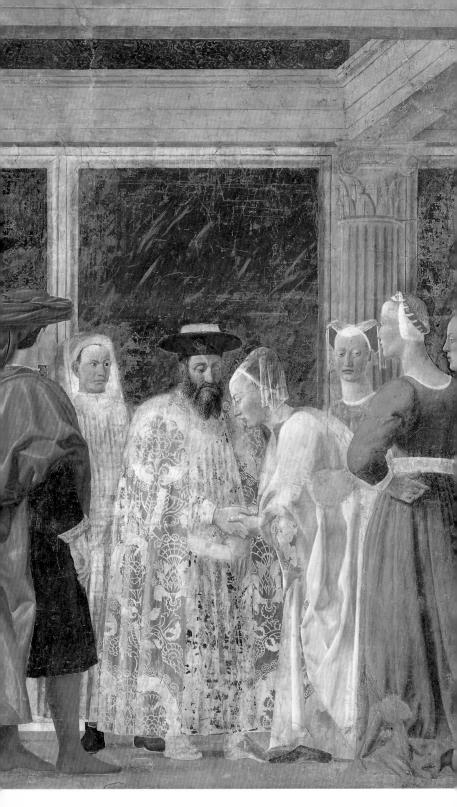

36 Piero: Detail from The Meeting of Solomon and the Queen of Sheba (pl. 21)

of the followers of Constantine seen against the sky are so graduated that they establish the depth of the whole scene. They indicate the size of an advancing army only a few of whose members are in fact portrayed. Enough of the right half of this fresco has been preserved to establish that the upright lances of the advancing army on the left were contrasted with the disorderly diagonal lances of the fleeing forces on the right and that the same contrast obtained between the steady tread of the horses on the left and the panic-stricken horses of Maxentius. The void between the armies is filled with a view of the receding river lit by sunlight of dazzling purity, for which the only earlier parallel occurs in Piero's work in the view of the Castle of Rimini in the fresco of Sigismondo Malatesta before St Sigismund. But there is no analogy at Rimini or indeed elsewhere for the fresco of The Dream of Constantine on the altar wall to the left of The Victory of Constantine. This is a night scene in which the Emperor's tent, the sleeping Emperor and the upper half of a guard sitting beside the bed are illuminated by the radiance of an angel in the upper left-hand corner of the scene. It has been

37 Piero: Landscape, detail from The Victory of Constantine over Maxentius (pl. 23)

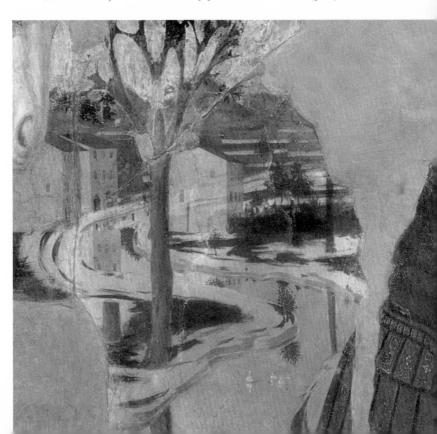

suggested (convincingly I think) that the use of artificial light proves Piero to have been familiar with French manuscripts from the circle of Fouquet, which he would have seen not at Arezzo but at some central Italian court; a partial parallel for it occurs in a miniature in a Riminese copy of Basinio's *Hesperides* in Paris.

Fresco, true fresco, is normally a rapid medium. The preparatory process, the artistic thinking, the making of preliminary drawings might take time, but the speed of execution was determined by the day or days in which the intonaco (the plaster) could be kept damp enough to absorb paint. After it dried surface additions could be made a secco, but they were recognized to be less durable than the paint layer beneath. Piero della Francesca was a slow painter in every sense. Not only was the execution of his major works protracted over an unprecedentedly long period of time—the San Sepolcro polyptych of the Madonna of Mercy seems to have been in course of execution for up to fifteen years—but in fresco the individual heads were also worked up with the utmost care. Some impression of the process can be gained from recent ultra-violet and infra-red photographs of the Arezzo frescoes, in some of which the preliminary spolvero (powder dusted through a pricked cartoon) of the intonaco is visible. Some of the best examples occur in the portraits of members of the Bacci family in the Victory of Heraclius over Chosroes. Piero's slow technique was inimical to action, and the original intention behind a figure like that of one of Chosroes' sons being pierced in the neck by a follower of Heraclius can only be recovered by comparing the finished figure with the drawing underneath that an infra-red photograph reveals. Sometimes, however, a sense of spontaneity could be preserved, as the juxtaposition of the frightened head of one of Maxentius's soldiers with an ultra-violet photograph of the same figure clearly shows. Piero was anything but a descriptive artist, and in a number of the women's heads in the Meeting of Solomon and the Queen of Sheba the same cartoon is repeated in reverse. The motive may have been desire for a generalized pattern-like image that would not distract attention from the central scene.

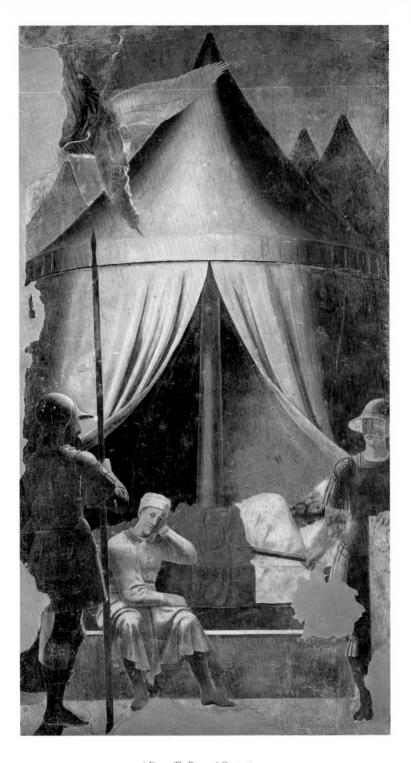

38 Piero: *The Dream of Constantine.* Arezzo

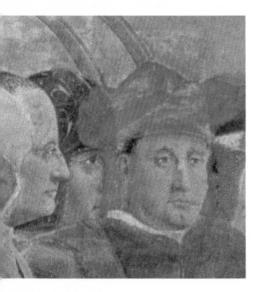

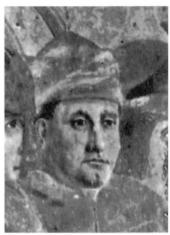

39, 40 Members of the Bacci family, detail from *The Victory of Heraclius over Chosroes* (pl. 22), with (right) an infra-red photograph

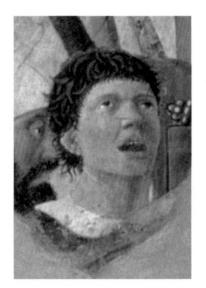

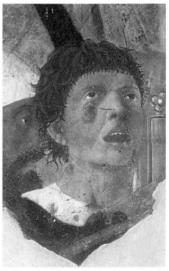

41, 42 Detail from *The Victory of Constantine over Maxentius* (pl. 23), with (right) an ultra-violet photograph

A great deal of time has been devoted, in anticipation of the centenary of Piero's death in 1992, to investigating exactly how his frescoes were meant to look. One of the most fruitful studies has been that of the Madonna del Parto at Monterchi, where much of the secco overpainting has been lost.12 It has been argued that the Virgin's dress and the curtains and the angels are the work of an assistant, but this results from a misreading of their state. Recent infra-red and ultra-violet photographs have made it possible to reconstruct the secco painting that was originally there. They establish that the patterning of the curtains was far richer than it appears today. The lost secco painting affected, not just the surface of the fresco, but the volume of the canopy. Originally the stance of the Virgin was more clearly defined, and her headdress was more elaborate; it hung down at either side, rather like the headdresses one sees in dugento Aretine paintings, while her two hands must have read more delicately than they do today. The imagery is, I suspect, less puzzling than is generally supposed. At just about this time Donatello modelled, for the high altar of Sant'Antonio at Padua, a Virgin rising from her seat holding the newborn Child in front of her before her womb. This literal illustration of the verse from the Salve Regina—'Show unto us the blessed fruit of thy womb, Jesus'—is also the subject of the Monterchi fresco, save that in the fresco the birth is imminent and has not yet taken place. The two angels, pulling away the curtains that conceal the Virgin, are figures of great strength. As

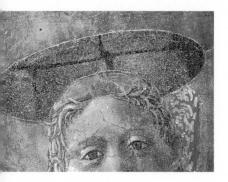

43, 44 Infra-red photographs of two details, an angel's head and the curtain from *Madonna del Parto*.

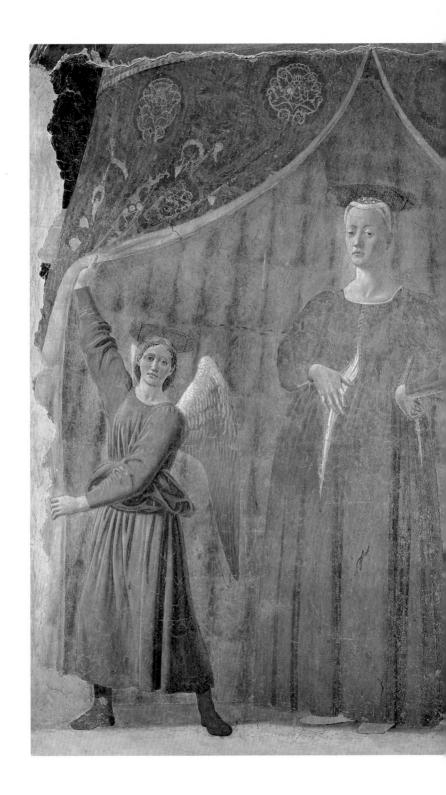

45 Piero: Madonna del Parto. Monterchi

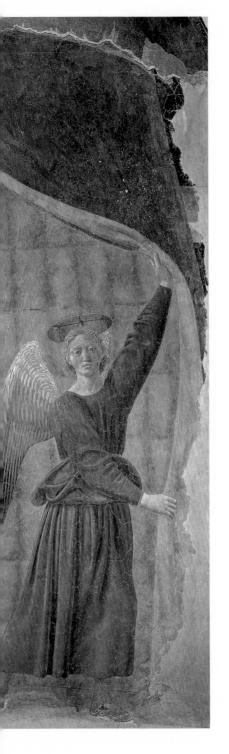

46 Donatello: Virgin and Child. Sant'Antonio, Padua

we look at the right-hand angel—and especially at the head, seen in close-up with the space-defining halo—the authority of the design speaks for itself. The features of the angel on the left—the mouth, the ears, the wiry hair—are also incomparably strong.

Physical analysis is important—it explains how works of art are executed—but intellectual analysis is more important still. People writing about works of art have a bias toward supposing that great paintings like Piero's must be inspired by great ideas or events. One such case is the *Baptism of Christ* in the National Gallery. It was commissioned by a family called Graziani for a Camaldolite church in San Sepolcro, and was inspired by an earlier polyptych for another Camaldolite church (between San Sepolcro and Arezzo) by Niccolò di Pietro Gerini, which also displayed the *Baptism of Christ* as its centre-

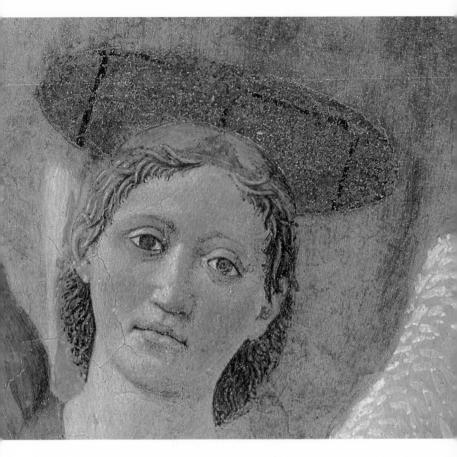

47 Detail of one of the angels in the Madonna del Parto (pl. 45)

piece. Piero's *Baptism* was also almost certainly intended as the centre of a polyptych, the rest of which was carried out about 1455, not by Piero himself, but by Matteo di Giovanni, and is today preserved at Borgo San Sepolcro. But in the isolated form in which we know it, Piero's *Baptism* is one of the supreme masterpieces of Italian painting. It has been argued, simply for that reason, that its meaning differs from that of other Baptisms, that it is a parable of the Council of Florence, representing the reconciliation of the Eastern and the Western Churches and was inspired by the main proponent of the Council, Ambrogio Traversari. There is not a shred of valid evidence for that, and it has been shown (to my mind quite conclusively) by B.A.R. Carter that its uniqueness derives not from the ideas that it embodies, but from the way in which it was designed.¹³

48 Niccolò di Pietro Gerini: Triptych with the *Baptism of Christ*. National Gallery, London

On his posthumous portrait at San Sepolcro Piero is described as one who amplified, or extended, arithmetic and geometry as well as painting. He may, if a passage in Vasari is to be trusted, have started life as a kind of mathematical prodigy, and his two treatises, on perspective and on the five regular bodies, the *De Prospettiva Pingendi* and the *De Quinque Corporibus Regularibus*, are milestones in the history of geometry and mathematics. They exercised, through an adaptation by Fra Luca Pacioli, a deep influence in the sixteenth century. In one sense this was an ordinary interest raised to a higher power. Cities like Arezzo employed masters of the abacus, who taught arithmetic, geometry and algebra to the level that was necessary for successful mercan-

tile activity. But Piero della Francesca's work on geometry is infinitely more demanding. He knew Euclid well, as we know from his commentary on the five propositions from the fifteenth book of Euclid's Elements; he understood biquadratic equations; and he seems to have believed that the five regular bodies had the cosmological significance outlined in Plato's Timaeus. All this, as an excellent geometrical analysis by Dr Carter has proved, was fundamental for the planning of the Baptism of Christ. Here indeed, we can abandon speculation and descend to fact, for it has been shown that the proportions of the composition were dictated by the width of the panel, two braccia exactly, that the composition below the springing of the arch was planned as a rectangle with a semi-circle superimposed, that the height of Christ is one and a half braccia, that the spaces at the sides are one third of the height of Christ-half a braccia each, that is-that in the rectangle use was made of a fifteen-sided equilateral, equiangular constructions that the radius of the semi-circle was also preordained, and that the dominance of the figure of Christ results, as it does also in the Resurrection fresco, from the vision of Christ as Sol Invictus in mathematical terms. To the naked eye the result has a finality that is due not to the painter's imagination, but to his geometrical consistency. Similarly it has been shown, again in a perfectly conclusive fashion, that the basis of the Madonna del Parto at Monterchi is a dodecahedron, and that the structure of The Dream of St Jerome is also rigorously geometrical. With Piero the linkage between art and science is closer and more purposeful than with any other artist.

I once went to a concert with someone who had the honesty, or the temerity, to say: 'One doesn't come to concerts to listen to the music.' She meant, of course, that music, by virtue of its inherent logic and its intervals, induced a pleasure, a sense of exaltation or reflection or passivity that was independent of all knowledge of the score. Most people's approach to Piero is, it seems to me, of somewhat the same kind. If they are relatively unsophisticated, like the travellers in *Summer's Lease*, they stand in the oratory at Monterchi thinking about childbirth, and sit in the museum at San Sepolcro ruminating about rebirth, the

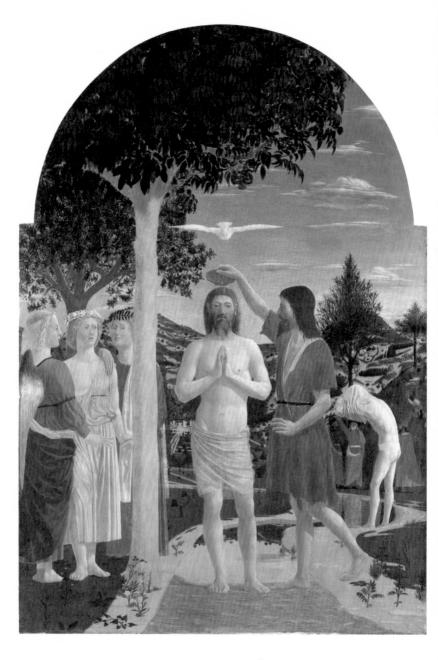

49 Piero: *Baptism of Christ*. National Gallery, London

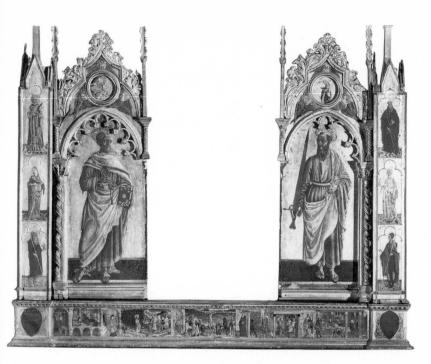

50 Matteo di Giovanni: Altarpiece. Museo Civico, Borgo San Sepolcro, formerly including Piero's *Baptism*

cycle of seasons or pagan mysteries. If they are scholars they roam more widely. They imagine that the Tiber valley in the background of *The Baptism of Christ* is intended as an earthly paradise, that the robed figures in the middle distance, though there are four of them, are the Three Magi, that the angels at the side are guests at the Marriage at Cana, and that the catechumen behind Christ is putting on, not taking off, his shirt. They misinterpret every one of the details in the background of the so-called *Flagellation*, and they believe the curtains in the *Madonna* at Monterchi to be lined with ermine (the lining seems actually to be a commonplace fur) and therefore to allude to the doctrine of the Immaculate Conception. To the best of my belief scholars and non-scholars do not respond in quite this way to any other artist, and I hesitate for that reason to put forward my own heterodox view that Piero's paintings, great works as they are, represent no more than they appear to represent and mean no more than they appear to represent and mean no more than they appear to represent and

Piero was, as *The Baptism of Christ* shows clearly, an artist of unrivalled visual sensibility, and nowhere more manifestly than in the

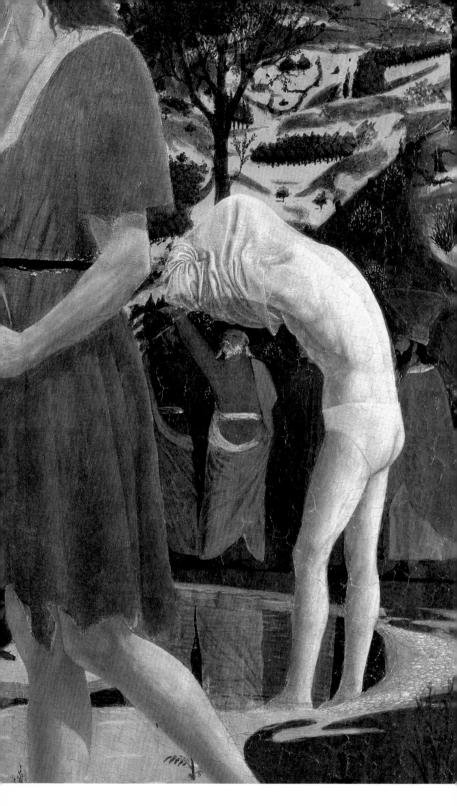

51 Man taking off his shirt, detail from the Baptism (pl. 49)

52 Pollaiuolo: Landscape view of the Arno valley, detail from an *Annunciation*. Gemäldegalerie, Staatliche Museen, Berlin

landscape of this painting. The books tell us that it represents the Valle Tiberina, and so no doubt it does. But the Valle Tiberina does not, to eyes conditioned by photography, look in the least like this; just as in portraiture Piero was content, until quite late in his career, to produce a generalized portrait image, so here his concern is with generalized landscape. It offers (and was intended to offer) a sharp contrast to the descriptive landscapes produced by Pollaiuolo in Florence at about this time. But in what would have been thought of in the fifteenth century as old age (advanced middle age to us), a change occurred. It happened in the 1470s at Urbino, and seems to have been due to the adoption of the medium of oil paint (or, more strictly speaking, tempera with a much larger oil component than had previously been used). The attraction of oil paint in the late 1460s was that it permitted, indeed encouraged, a type of particularized visual description that had not been possible before. This radically affected Piero's later works. When, for example, he painted the portraits of Battista Sforza and Federigo da Montefeltro that are now in the Uffizi, he set them against

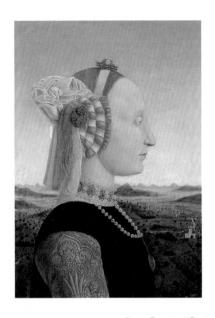

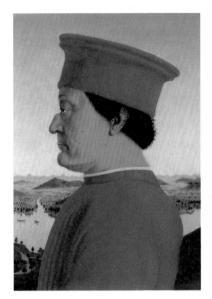

53, 54 Piero: Portraits of Battista Sforza and Federigo da Montefeltro. Uffizi, Florence

descriptive not conceptual landscapes, and he treated the reverses in the same way. The portraits were cleaned recently, and we know from one tiny area hidden by the frame that originally much of the detail was not brown but green. This change of medium was fundamental in two still later works, the *Montefeltro Altarpiece* in the Brera Gallery in Milan (a picture which has been almost destroyed by aggressive iconographers) and the little *Sinigallia Madonna* at Urbino.

At this point I must go back to Aldous Huxley. He believed, as a lot of people in those days did, that there was a thing called good art and another called bad art, and that Piero's late paintings represented a sort of descent towards the second category from the first. The portraits of the Duke and Duchess of Urbino were 'charming and exceedingly amusing' and the *Montefeltro Altarpiece* was not 'first-rate'. The shadow of this prejudice extends to Kenneth Clark's monograph on Piero (marginally less in the second edition than the first). In 1951 he found that the *Sinigallia Madonna*, 'grey and frozen though it is, shows in its background that some spark of interest in painting is still alight,' while the Brera altarpiece contained 'a set of stock figures, taken, one might almost suppose, from other works, and arranged in a row with-

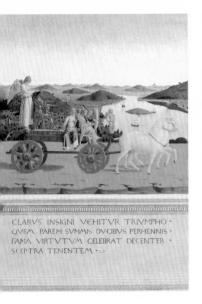

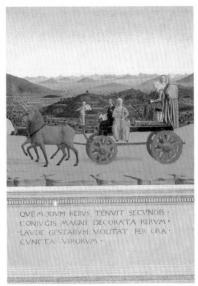

55, 56 Reverse of pl. 53 and 54, showing the Triumphs of the Duke and Duchess

out the least interest in the interplay of forms or outlines'.15 Admittedly, not long ago the Brera altarpiece was grossly overcleaned and deprived of a great deal of its luministic quality, but up to that time there could have been no doubt that it was one of the indisputable masterpieces of Renaissance painting. The design was built up in the same cerebral fashion as that of Piero's earlier paintings—there is a drawing in the De Prospettiva Pingendi which shows the kind of thinking that was involved. It was noble, it was spacious, it was solid, and when it stood, as it originally did, first in San Donato and then in San Bernardino at Urbino, it was probably the most innovative altarpiece in the whole of Italy. Its majestic architecture, with no front plane, closed at the sides by the projecting cornices of the crossing of the church, the bold division of the apse into areas of light and shadow, relieved by the surface of the exquisitely modelled ostrich egg, the six saints immersed in the whole scene—two of them, Saints Bernardino and Peter Martyr, do seem, though it has been denied, to have been interpolated by the artist into his original composition—the impassive figure of the Virgin, and the noble portrait of the Duke gazing (with rapt attention) at the sleeping child, open a new realm of

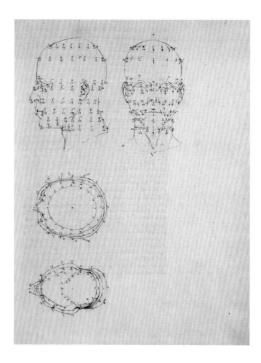

57 Drawings from Piero's De Prospettiva Pingendi showing the construction of a head

communication and expressiveness. It is no wonder that in Venice, which was of reasonably easy access from Urbino, the painting exercised a deep and continuing influence. This altarpiece is, however, a public painting, whereas the *Sinigallia Madonna* is one of the most private paintings that has ever been produced. Its soft illumination (the filtered light pours through the window on the left as it does in paintings produced by Vermeer two centuries later), its imagery (the Child is, in embryo, the muscular Redeemer of the *Resurrection*) and its spatial structure (the transposed architecture of the Ducal Palace at Urbino establishes the relation between the figures and their setting) are all of incomparable subtlety. Were we to play Huxley's futile game of naming the best pictures in the world, this little panel would certainly be on my list. What we are confronted by in these late works is an organic artistic growth, whose extent becomes self-evident if we compare them with the artist's earlier works.

These, then, are some of the problems that Piero's work presents. A great many of the written commentaries on it can be discarded,

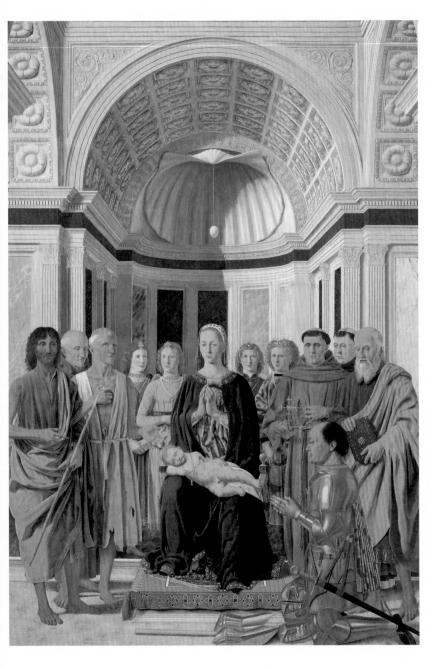

58 Piero: Madonna and Child with Saints (Montefeltro Altarpiece). Brera, Milan

above all the fantastic literature that has sprung up about his imagery. When I read them I recall Susan Sontag's essay 'Against Interpretation'. 'What is important now,' she writes, 'is to recover our senses. We must learn to see more, to hear more, to feel more. Our task is not to find the maximum content in a work of art, much less to squeeze more content out of the work than is already there . . . The aim of all commentary on art now should be to make works of art—and, by analogy, our own experience—more, rather than less, real to us.'16 Any account of meaning in Piero's paintings must be based, not on preconceptions, but on what is actually portrayed. From the standpoint of narrative Piero's language is a dialect which must be studied in its entirety if the facial expressions and the gestures he employs are not to be misunderstood. Four types of analysis are in fact involved. The first is structural analysis, which will prevent our falling into the same trap as Kenneth Clark, who illustrated and discussed the Arezzo frescoes back to front. in the sequence of the source, the Golden Legend, not in the sequence in which they were actually produced. The second is theoretical analysis, for which the point of departure are the teachings of Alberti on circumscription, which are applied with growing refinement by Piero throughout his life, and which, by 1470, gave rise to works of a subtlety and elaboration that Alberti in 1435 could hardly have conceived. The third is to establish the relevance of the artist's writings on geometry and mathematics to the figurative works that he produced. This was not a static equation; it was subject to change and is of particular importance for the discussion of undated works. The fourth is the challenge of two psychological factors that are inseparable: unwavering detachment and supreme visual sensibility. Tourists in their rented Fiats have neither the time nor the taste to look at Piero's work from any of these points of view, but, in conjunction, on a subconscious level, they explain the phenomenon of the trail and the pertinacity with which it is pursued.

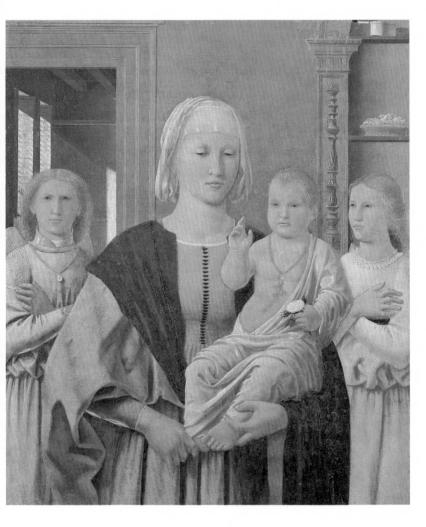

59 Piero: Madonna and Child (Sinigallia Madonna). Galleria Nazionale, Urbino

NOTES

- 1 Aldous Huxley, Along the Road, London 1925.
- 2 John Mortimer, Summer's Lease, London 1988, and for subsequent quotations.
- 3 St Jerome's letter to Eustochium is printed in *Select Letters of St Jerome*, ed. and trs. F.A. Wright, Cambridge 1980, pp. 125–29:

Even when I was on my way to Jerusalem to fight the good fight there, I could not bring myself to forgo the library which, with great care and labour, I had got together at Rome. And so, miserable man that I was, I would fast, only to read Cicero afterwards. I would spend many nights in vigil, I would shed bitter tears called from my innermost heart by the remembrance of my past sins, and then I would take up Plautus again. When I returned to my right senses and began to read the prophets, their language seems rough and barbarous . . . Suddenly I was caught up in the spirit and dragged before the Judge's judgment seat: and here the light was so dazzling, and the brightness shining from those who stood round so radiant, that I flung myself upon the ground and did not dare to look up. I was asked to state my condition and replied that I was a Christian. But He who presided said: 'Thou liest, thou art a Ciceronian not a Christian. For where thy treasure is, there will thy heart be also.' Straightforward I became dumb, and amid the strokes of the whip—for he had ordered me to be scourged—I was ever more bitterly tortured by the fire of conscience . . . I began to cry out and to bewail myself saying: 'Have mercy upon me, O Lord, have mercy upon me,' and even amid the noise of the lash my voice made itself heard. At last the bystanders fell at the knees of him who presided, and prayed Him to pardon my youth and give me the opportunity to repent my error on the understanding that the extreme of torture should be inflicted upon me if ever I read again the works of Gentile authors. In the stress of that dread hour I should have been willing to make even larger promises, and taking oath I called upon his name: 'O Lord, if ever again I possess worldly books or read them, I have denied thee.'

For Matteo di Giovanni's panel of the *Dream of St Jerome* see Erica Trimpi, 'Iohannem Baptistam Hieronymo aequalem et non maiorem: a predella for Matteo di Giovanni's Placidi altar-piece', The Burlington Magazine, CXXV, 1983, pp. 457–66; and Beatrice Wilcynski 'Matteo di Giovanni: Two Episodes from the Life of St Jerome', in *Art Institute of Chicago Quartely*, 50, 1956, pp. 74–6. The identification of the subject of Piero's panel as the *Dream of St Jerome* is discussed at length by John Pope-Hennessy, 'Whose Flagellation?', in *Apollo*, CXXIV, 1986, pp. 162–65.

- 4 Roberto Longhi, *Piero della Francesca*, Milan 1927 (new edition, Florence 1963); Kenneth Clark, *Piero della Francesca*, London 1951 (second edition, London 1969); Eugenio Battisti, *Piero della Francesca*, Milan 1971; Carlo Ginzburg, *Indagini su Piero*, Turin 1981 (English edition, *The Enigma of Piero*, trs. M. Ryle and K. Soper, London 1985; for a review of this see John Pope-Hennessy, 'The Mystery of a Master', in *The New Republic*, March 31, 1986, pp. 38–41).
- 5 R. Wittkower and B.A.R. Carter, 'The Perspective of Piero della Francesca's 'Flagellation', in Journal of the Warburg and Courtauld Institutes, XVI, 1953, pp. 292–302; B.A.R. Carter, 'A Mathematical Interpretation of Piero della Francesca's Baptism of Christ', in Marilyn Aronberg Lavin, Piero della Francesca's Baptism of Christ (New Haven and London 1981), pp. 149–63; James Elkins, 'Piero della Francesca and the Renaissance Proof of Linear Perspective', The Art Bulletin, LXIX, 1987, pp. 220–30.
- 6 Frank Dabell, 'Antonio d'Anghiari e gli inizi di Piero della Francesca', *Paragone*, XXXV (no. 417), 1984, pp. 73–94.

- 7 Leon Battista Alberti, On Painting and Sculpture, ed. and trs. C. Grayson, London 1972, p. 67.
- 8 idem, p. 89-91.
- 9 idem, p. 93.
- 10 idem, p. 79.
- 11 Clark, op. cit. (1969), p. 52.
- 12 The technical investigation of the Madonna del Parto is discussed in detail in Un progretto per Piero della Francesca: Indagini diagnostico-conoscitive per la conservazione della "Leggenda della Vera Croce e della Madonna del Parto", Margherita Moriondo Lenzini et al., Florence 1989. I should particularly like to thank Dr Maruizio Seracini for his help in procuring the infra-red and ultraviolet photographs.
- 13 B.A.R. Carter, op. cit.
- 14 Aldous Huxley, op. cit., Part III, 'The Best Picture'.
- 15 Clark, op cit. (1951), pp. 48-9.
- 16 Susan Sontag, 'Against Interpretation', in *Against Interpretation*, New York 1966; reprinted in *A Susan Sontag Reader*, New York 1983, p. 104.

Sir John Pope-Hennessy, one of the greatest art historians of the twentieth century and perhaps its greatest authority on Italian Renaissance art, was born in 1913. He served as Director of the Victoria and Albert Museum, Director of the British Museum and Consultative Chairman of the Department of European Paintings at the Metropolitan Museum of Art as well as Professor of Fine Arts at New York University. His many publications are now standard works of reference and include An Introduction to Italian Sculpture, Italian Gothic Sculpture, Italian Renaissance Sculpture, Italian High Renaissance and Baroque Sculpture, Cellini, many monographs and his masterwork, Donatello. Sir John died in 1995.

Aldous Huxley (1894–1963), the British author, traveled widely and lived in Italy during the 1920s. He lived in California starting in the 1930s and is best known for *Point Counter Point, Brave New World* and *After Many a Summer Dies the Swan*.

PICTURE CREDITS

- Cover, frontispiece and all plates except those noted below: Scala/Art Resource, New York
- Page 17 (pl. 3) Matteo di Giovanni (act. 1452–1495), Italian (Sienese), *The Dream of Saint Jerome*, 1476, tempera on panel, 37.4 x 65.7 cm, painted surface 35.8 x 64.4 cm.

 Mr. and Mrs. Martin A. Ryerson Collection, 1933.1018. Photograph courtesy of The Art Institute of Chicago. All rights reserved.
 - Page 18 (pl. 4) Piero della Francesca (1410/1420–1492) (or workshop), Italian, *The Crucifixion*, tempera on panel (irregular), 14¾ x 16¾ in. (37.5 x 41.1 cm). Bequest of John D. Rockefeller Jr. in 1961. © The Frick Collection, New York
- Page 20 (pl. 6) Piero della Francesca (about 1415/20–1492), Saint Michael, oil (identified) on wood, 133 x 59.5 cm. © National Gallery, London
- Page 21 (pl. 7) Piero della Francesca (1410/1420–1492), Italian, Saint John the Evangelist, between 1454 and 1469, tempera on panel, 52¾ x 24½ in. (134 x 62.2 cm).

 Purchased in 1936, accession number: 36.1.138. © The Frick Collection, New York
 - Page 27 (pl. 13) Piero della Francesca (c. 1419/21–92), *Hercules*, c. 1475 (fresco), Isabella Stewart Gardner Museum, Boston, Massachusetts. The Bridgeman Art Library International Ltd.
- Page 28 (pl. 14) Masaccio (1401–probably 1428), *The Virgin and Child*, tempera on wood, 135.5 x 73.0 cm. © National Gallery, London
- Page 66 (pl. 48) Niccolò di Pietro Gerini (active 1368; died 1415), triptych; *The Baptism of Christ*, tempera on wood, 89.5 x 37.5 cm. © National Gallery, London
 - Page 68 (pl. 49) and Page 70 (pl. 51 [detail of pl. 49]) Piero della Francesca (about 1415/20–1492), *The Baptism of Christ*, egg (identified) on panel, 167 x 116 cm.
 © National Gallery, London
 - Page 71 (pl. 52) Pallauiolo, *Landscape View of the Arno Valley* (detail of *Annunciation*), Staatliche Museen zu Berlin-Preußischer Kulturbesitz Gemäldegalerie. Photo: Jörg P. Anders
- Page 60 (pl. 40, 42) and Page 61 (pl. 43, 44) were unable to be located and were scanned from the original edition of *The Piero della Francesca Trail*.

THE PIERO DELLA FRANCESCA TRAIL WAS DESIGNED AND TYPESET BY KATY HOMANS AND PRINTED ON GARDAPAT PAPER UNDER THE SUPERVISION OF SUE MEDLICOTT AT TRIFOLIO, VERONA, ITALY.

A NOTE ON THE TYPOGRAPHY

Monotype Centaur was designed by Bruce Rogers for hand composition

(capitals only) in 1914 for the Metropolitan Museum of Art,
and for monotype composition by the Monotype Corporation in 1929.

It is based on the original font designed by Nicolaus Jenson in Venice, 1470.

The italic (originally called Arrighi) was cut from a model of fifty years later,
inspired by a version used in 1524 by Ludovicio degli Arrighi.

TRAVEL BOOKS FROM THE LITTLE BOOKROOM

City Secrets London
ISBN 1-892145-07-3

City Secrets Florence, Venice and the Towns of Italy
ISBN 1-892145-01-4

City Secrets Rome

Robert Kahn, Series Editor

Artists in Residence by Dana Micucci ISBN 1-892145-00-6

The Historic Restaurants of Paris
ISBN 1-892145-03-0

Picasso's Paris ISBN 0-9641262-7-3

The Impressionists' Paris ISBN 0-9641262-2-2

by Ellen Williams

A House on the Heights by Truman Capote with an introduction by George Plimpton ISBN 1-892145-24-3

Harpo Speaks . . . about New York
by Harpo Marx
with an introduction by E. L. Doctorow
ISBN 1-892145-06-5

Here is New York
by E. B. White
with an introduction by Roger Angell
ISBN 1-892145-02-2

For a complete catalog, contact
The Little Bookroom
5 St. Luke's Place
New York NY 10014
212-691-3321phone
212-691-2011 fax
book-room@rcn.com